Shopping with Freud

Consumer choice is regularly taken to be different from other kinds of choice – and not only different, but inferior and relatively trivial. So choosing to have a baby is unlike choosing a new car, and choosing to study a work of great literature is unlike 'merely' consuming a trash novel. In such comparisons, consumption is simple; and its supposed simplicity is necessary to establish the complexity and value of the other, 'higher' category of choice.

Yet if consumer choice were simple, the vast institutional field of 'consumer psychology' would never have developed. *Shopping with Freud* examines some of the dramatic ways in which the consumer subject was first imagined and analysed by this special area of psychology.

Once the simplicity of the consumerly is seen as a symptom rather than a given, new possibilities for thinking through ethical and other questions of choice emerge. The book looks at the diverse and unexpectedly overlapping ideas of choice and consumer choice deployed in consumer psychology and psychoanalysis, in arguments about the new reproductive technologies, and in arguments about literature and sexuality.

Rachel Bowlby is Reader in English at Sussex University.

Shopping with Freud

Rachel Bowlby

London and New York

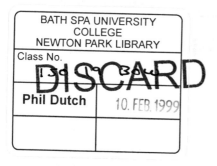
First published 1993 by
Routledge
11 New Fetter Lane, London EC4P 4EE

Simultaneously published in the USA and Canada
by Routledge Inc.
29 West 35th Street, New York, NY 10001

Typeset in Palatino by
Ponting–Green Publishing Services, Chesham, Bucks
Printed and bound in Great Britain by
Clays Ltd, St Ives plc
Printed on acid free paper

British Library Cataloguing in Publication Data
Bowlby, Rachel
 Shopping with Freud
 I. Title
 153.83

Library of Congress Cataloging in Publication Data
Bowlby, Rachel,
 Shopping with Freud / Rachel Bowlby.
 p. cm.
 Includes bibliographical references and index.
 1. Advertising–Psychological aspects. 2. Consumer behavior.
 I. Title.
 HF5822.B83 1993
 658.8'342–dc20 92-37663
 CIP

ISBN 0–415–06006–0
 0–415–06007–9 (pbk)

Contents

Acknowledgements

The thanks I owe to friends and colleagues for contributions of various kinds to the chapters of this book and *Still Crazy After All These Years*, its companion volume, extend so far back and to so many kinds of commercial and other spaces that I would not know where to begin if I were to try to acknowledge them all. Needless to say, it is no one's fault but my own if either book is a bad buy. But I would like to risk expressing my gratitude, all the same, to the Society of the Humanities at Cornell University, where the year devoted to 'The Humanities and the Challenge of Mass Culture' in 1990–1 gave me the chance of thinking and talking through many of the issues of both books, inside and outside Ithaca's malls: I thank in particular Jonathan Culler, Alex Doty, Jane Feuer, Simon Frith, Mary Jacobus, Dominick LaCapra, Laura Mulvey, Constance Penley, Shirley Samuels and Mark Seltzer. Among colleagues at Sussex, it is even more difficult to distinguish consumerly from intellectual exchanges. But whatever it was, I thank John Barrell, Geoff Bennington, Jonathan Dollimore, Pete Nicholls, Marcia Pointon, Jacqueline Rose, Alan Sinfield and Nancy Wood. I would also like to express my thanks for their criticism and support to Parveen Adams, Françoise Defromont, Cora Kaplan and Laura Marcus; and also, very directly, to Janice Price, Talia Rodgers and Sue Roe of Routledge for their unfailingly constructive urging.

Chapter 2 of this book, 'Promoting Dorian Gray', first appeared in *The Oxford Literary Review*, vol. 9 (1987), and chapter 5, 'A happy event', in *Paragraph*, vol. 14, no. 1 (March 1991). A different version of chapter 3, '"But she could have been reading Lady Chatterley"', was published in *Decolonizing Tradition: New Views of Twentieth-Century 'British' Literary Canons*, ed. Karen R. Lawrence (Urbana and Chicago: University of Illinois Press, 1991). The author gratefully acknowledges permission to reprint.

Chapter 1

Introduction

In Aldous Huxley's *Brave New World* (1932), the choiceless population engineered by the wonders or horrors of an almost flawless technology of test-tube reproduction is conditioned into an automatic reverence for a being who has two names: 'Our Ford – or Our Freud, as for some inscrutable reason he chose to call himself whenever he spoke of psychological matters.'[1] By the 1930s, it is feasible to imagine a partnership to the point of identification between on the one hand a psychology typified by psychoanalysis and on the other the mass production and consumption suggested by the car; and the association is appropriately encapsulated by one of the verbal techniques of modern publicity, the sloganizing style of a near-homonym. The Ford–Freud doubling suggests that consumption and psychology together made or will make the late-modern world: that for all practical purposes (and there are no others) they are one.

In Huxley's dystopia, actual automobiles have long since been superseded by private flying machines, and the fathers, mothers and other familial encumbrances of interest to Freud and his contemporaries have been replaced by more efficient modes of infantile training. But the now primitive Fordian–Freudian period is viewed as the beginning of a process completed by the standardized production of people as well as cars. The mass production and mass consumption epitomized in its 1930s version by the Ford is matched by a mass applied psychology aimed at the production of happy worker–consumers.

Huxley's humans, carefully stratified from alpha to epsilon, are made (not born) to consume what they are also made to produce; the nearest they come to free association is the random regurgitation of the buy-more injunctions they take in with their juvenile

sleep: '"I do love flying," they whispered, "I do love having new clothes, I do love ..."' (49). A faint possibility of difference or resistance, already indicated by the weary irony of the title, is personified principally in the form of a 'savage' who has been fortunate enough to fall on the complete works of Shakespeare, a treasure-trove of formulae that the novel unhesitatingly endorses as being of a higher quality than those available to the rest of the world in the form of advertising clichés.

Women have no part in these gestures towards the possibility of resistance: even the unfortunate Linda, rediscovered after years of abandonment in the 'Reservation' outside 'civilization', and mother of the smart Shakespearean savage, remains faithful to the last to her early indoctrinations, providing the novel instead with the occasion for an excursion into misogynist grotesque, as her body reveals signs of age and obesity unknown to the newer world. Yet this does not imply any approval of more modern modes of feminization. The technologization of reproduction – no natural births, and a process of rearing that is scientifically controlled – is dramatically staged as the novel's opening spectacle, exemplifying the most fundamental aspect of the deprivation of a freedom characterized as freedom of choice.

In this fantasy of a totally engineered human condition, consumption and psychology are indissoluble partners, united in a conspiracy which can be challenged only by the dismissal of both as agencies which are as pernicious and uniform as are their assumed effects. Humans are duped and drugged into a spurious consumerly conformity and happiness which is most effective in relation to women, and against which only literature might provide the tiny chance of another way of thinking. In these contexts, Huxley's novel brings together with clarity and simplicity most of the common connections and questions which form the background to this book.

The Foreword Huxley wrote for *Brave New World* in 1946, having outlined three possible future scenarios for world developments, concludes with the telling words: 'You pays your money and you takes your choice' (14). The pseudo-demotic irony of this does not alter the fact that consumer choice has become the paradigm for ethical and political choice. In this regard, Huxley perhaps saw truer than in any of his wilder (or more civilized) new-world imaginings. For in Britain more recently, the word 'consumer' has entered everyday public language under many

new guises. Margaret Thatcher's 1980s vision of a society, or collection of individuals, granted 'more and more choice' has been accompanied by an increasing tendency for people to be addressed as 'consumers' whatever their activity. Not just when we are shopping, but when we are voters, students, patients, parents, citizens of all sorts, we are now to identify ourselves as consumers, and that term is supposed to give us rights from which we were previously debarred.

This positive consumer is the direct antithesis of an earlier manifestation of the word. The consumer invoked in relation to 'postwar consumer society' was not the summit of rational individuality, but a poor dupe, deluded by the onslaught of an irresistible and insidious advertising industry. S/he was to be rescued from her distraction, restored if possible to the capacity for reasonable behaviour of which the forces of consumerism were busy depriving her or him. This second, passive and deluded consumer has not disappeared from the contemporary picture: there are still many denunciations of the latest forms of consumer manipulations taking place alongside the endorsements of modern consumer citizenship. Equally, the new figure of consumer rationality can be seen to have a prehistory when we look back to the earlier period: in the 1960s, there were organizations acting on behalf of 'consumer rights' which opposed to the model of the captivated consumer that of the consumer as someone making sensible choices.

As the final chapter discusses in more detail, diametrically opposed views of choice are implied by the two views of the consumer outlined above. In one, s/he has no choice: the choice is imposed, even if it feels like spontaneous desire. In the other, s/he has full powers of choice and is restricted only by lack of information. But at the same time, these two versions rotate around the same two poles of control or abandon, full information or utter impressionability. There is more to say about the possibilities and limits of having or making a choice; and this is what brings consumption straight into the territory of psychology.

The question that advertisers have been asking throughout this century – 'what persuades someone to choose to buy?' – involves issues about the nature of human psychology parallel to those which preoccupy critics of consumerism, as well as psychologists of all kinds. When Vance Packard, in 1957, denounced the insidious effects of 'manipulation' in advertising, he used the

manipulators' own psychology, accepting that people can be persuaded against their conscious will; the only difference between Packard and his enemies is in the moral terms (he thinks they are wrong to use that power). More gently, when Betty Friedan a few years later deplored the effects of women's magazines and other institutions in promoting a feeble, domesticated kind of femininity, she did so by setting up and promoting her own image of what a woman really is in its place. Both their books – *The Hidden Persuaders* and *The Feminine Mystique* – were bestsellers, functioning as successful advertisements themselves: Friedan's is generally thought of as the book which launched the 'second wave' of feminism in the United States and Europe. The critic has to become a persuader, hidden or not, in order to make the case against the persuaders.

What this further suggests is that a straightforward denunciation of consumerism is missing the point: one form of persuasion is simply doubled by another that claims superior force. It suggests too that far from advertising getting it wrong (in a moral sense or a factual sense), this vast twentieth-century organization may have pointed the way to arguments about human psychology in fields we think of as far removed from those of commercial machinations and manipulations.

This book then explores some of the ways that issues of consumer choice, and of choice in general, are implicitly or overtly explored in literature and in writing about psychology and marketing. The chapter on Oscar Wilde's *The Picture of Dorian Gray* (1891) reads this novel in terms of a relation between aestheticism and the consumerism beginning to develop at the time. The aesthetically perfect youth is the prototype of the ideal narcissistic consumer created and targeted by one form of advertising: you who can look like this, have and do anything you want, with no restraints and no consequences. The 1960 British trial of D.H. Lawrence's *Lady Chatterley's Lover*, which is the subject of the next chapter, involves revealing permutations of the terms pornography, literature, consumption and sexuality which are directly related to what goes on in the novel itself. Consumption and pornography have to be dismissed as the vulgar dirt that then enables the uneasy claiming of great literature and healthy relationships in their absolute difference. Nabokov's *Lolita*, another novel that was controversial at the turn of the 1960s, takes these terms in a different direction. As with *Dorian Gray*, this is the

story of a connection between eroticism, youthful aesthetic perfection and the pleasures of limitless consuming. And as with *Lady Chatterley*, the question of pornography hovers around something which is also a question of consumerism – in *Lolita* very directly, with Lolita's consuming American vulgarity represented (at least ostensibly) as the antithesis of the narrator's European intellectual superiority.

'A happy event', which looks at Freud's writings on the break-up between himself and Josef Breuer over the 'Anna O' case, puts questions about the nature of the wish or the choice to have a child which are then connected to the current debates around the new reproductive technologies and the kinds of choice they imply. The choice to have a child tends to be seen according to one of three categories. Either it is imposed (by society), or it is spontaneous (a matter of biological urges), or else it is simply placed on a par with other sensible (not impulsive) human choices. The different light that might be cast by a psychoanalytic way of thinking about this brings the book round full circle, returning from the other direction to the question of how different notions of choice deployed in discussions of consumption, feminism and psychoanalysis need to be looked at all together, in their overlaps and in the ways that they illuminate and challenge one another.

The final chapter, 'Make up your mind', explores some of the ramifications of the shopping-and-psychology connections appearing on both sides of the Atlantic at the time of Huxley's writing, when Freud's works – among many others – were already being taken up by marketing theorists as clues to the understanding of the minds of potential buyers. Putting their writings into relation with the psychoanalytic theory which was developing at the same time leads to some concluding questions about the habitual forgetting or simplification of notions of consumerism within other discourses. The marketing concern to discover what might persuade people to make purchases was intimately bound up, both institutionally and intellectually, with the contemporary psychoanalytical focus on the conscious and unconscious determinants of choices in life and love. There is a consumer subject in Freud who has not been noticed as such; but to say this is not to claim that psychoanalysis should be equated with or subordinated to consumerism.

For as I will hope to have demonstrated by now in the book's various contexts, consumption is in no way simple or single, and

part of the aim will have been to point out the tendency in relation to many kinds of argument either to dismiss it as beneath attention, or to overlook it as something which needs no analysis. This is as true of literature, criticism and feminist theory as it is of other fields: secret shoppers can be tracked down in the most unlikely discursive locations, just as other kinds of consumer may be visibly planted at strategic moments for the purposes of simplifying a discussion.

The elision of consumption as something not worth thinking about and not needing thinking about is indicative of a wish – one which itself requires explanation – to set consumerism off in a separate category, as a mere adjunct to psychology rather than as something which inflects its workings and possibilities at every turn. In the late twentieth century, consumption and psychology are as inseparable, and as all-pervasive in both a quotidian and a global sense, as they already appeared to be in the 1930s. But they are in no way as monolithic, either separately or together, as Huxley imagined them. This book is an attempt to look more closely at some of the odder elements omitted from the conveniently standardized label.

Chapter 2

Promoting Dorian Gray

A cigarette is the perfect type of the perfect pleasure. It is exquisite, and it leaves one unsatisfied.[1]

These words, spoken by a character in Oscar Wilde's *The Picture of Dorian Gray* (1891), grant to a much maligned weed a status possibly higher than any it has known before or since, and may well strike the late-twentieth-century reader as rather strong. In representing the cigarette not only as a pleasure, but as the very quintessence of pleasure, they make the kind of exorbitant claim associated not so much with the refinement of aestheticism as with the advertisement's 'unique selling point'. It might seem natural to draw a distinction between aestheticism and advertising, identifying the latter with all the vulgarity rejected by the defenders of 'art for art's sake'. In this chapter, I shall draw on Wilde's *Picture* and draw on the cigarette to try to show the relative convergence of the two, both as practices and as philosophies. The aesthete, far from being different from the new consumer of the period, turns out to be none other than his or her 'perfect type'.[2]

The cigarette is itself a case in point. One of the most ubiquitous and widely advertised commodities of the late nineteenth century, it none the less occupies a prominent and honourable position in the work of an avowed critic of vulgarity. Apart from Lord Henry's epigrammatic eulogy, the utterances of the most tasteful characters in Wilde's novel are punctuated throughout by reference to their sophisticated modes of lighting up.[3]

The punchline of Wilde's aphorism could be taken as an analysis in miniature of the mechanism upon which advertising depends. The enjoyment of the 'perfect pleasure' results not in

satisfaction but in a lack of it, leaving open the demand for more, the search for the next (or the same) short-lived and necessarily incomplete pleasure. In its structure, the aphorism itself reproduces the process it describes. Short and quick, like the cigarette, it operates by means of an apparent non sequitur: pleasure entails *non*-satisfaction. The paradoxical disruption of common sense constitutes both its appeal, what makes it distinctive, and its tantalizing refusal of the explanation which would also remove the source of that appeal.

Formally, then, the aphorism repeats the effects of pleasure and non-satisfaction attributed to its subject, securing a renewed quest for more satisfaction, be it of word or mouth. Lord Henry's view of the cigarette points, in fact, towards concerns engaging advertisers and aesthetes alike. 'Pleasure' and the 'exquisite' of beauty are two; a third is the question of representation. Wilde was violently opposed to the 'vulgar realism' he caricatured in 'the man who could call a spade a spade' (215). Overturning what he thereby mocked as Arnoldian literalism, he defined the purposes of art as 'to see the object as in itself it really is not'.[4] His concern, like that of the advertiser, was with making the object appear beautiful, presenting it as anything but the hypothetical 'object in itself'. The cigarette, as 'the perfect pleasure', could in a sense have been anything else; alternatively, the list of its virtues might have been multiplied or varied *ad infinitum*.

Calling a cigarette a cigarette would be as dull, in this regard, as calling a spade a spade, and Wilde's novel demonstrates the untenability as well as the banality of any supposition of a fixed identity for things or people once they have been situated within any order of representation. The cigarette, again, is an apt illustration. It could connote the indolence of the beautiful life of the dandy but also, in another context, the sexually transgressive associations of the independent 'new woman' of the period. Rarely, if ever, is a cigarette only a cigarette: individuals, like objects, are open to any and every kind of verbal or visual portrayal without there being any original nature which the picture might be said to misrepresent. 'It is simply expression which gives reality to things' (121), declares Lord Henry; 'Words! Mere words! . . . Was there anything so real as words?' He refuses the mock title of Prince Paradox not on the grounds of inaccuracy but because 'Names are everything' and because 'From a label there is no escape' (215). The commercial-aesthetic etiquette of the

label tickets human and other articles with tags that are quite arbitrary in their lack of relation to a prior essence. The case of Sybil Vane, the actress with whom Dorian falls in love, shows the impossibility within the terms of the novel of anything like an 'authentic' personality. Initially, Sybil appeals by appearing as anyone but Sybil Vane:

> Night after night I go to see her play. One evening she is Rosalind, and the next evening she is Imogen. I have seen her die in the gloom of an Italian tomb, sucking the poison from her lover's lips. I have watched her wandering through the forest of Arden, disguised as a pretty boy in hose and doublet and dainty cap. She has been mad, and has come into the presence of a guilty king, and given him rue to wear, and bitter herbs to taste of. She has been innocent, and the black hands of jealousy have crushed her reed-like throat. I have seen her in every age and in every costume. Ordinary women never appeal to one's imagination. They are limited to their century. No glamour ever transfigures them. One knows their minds as easily as one knows their bonnets. One can always find them. There is no mystery in any of them. They ride in the Park in the morning, and chatter at tea-parties in the afternoon. They have their stereotyped smile, and their fashionable manner. They are quite obvious. But an actress! How different an actress is!
>
> (60)

Sybil's multiple, ever-changing identities are themselves already fictional, Shakespeare's female heroines figuring for Dorian in a spectacular history of 'every age and every costume'. An artistic identity may itself be a cover for another, as when Sybil plays Rosalind playing a boy, and the sexual ambiguity confirms the 'mystery' attached to a someone known only as a discontinuous series of scripts and costumes, parts without a unifying whole. Against the lure of the mystery woman, or the woman as mystery, is set the 'stereotyped' banality and predictability of 'ordinary women', whose daytime transparency of repeated routines and identical clothes and manners bears no comparison to Sybil's shifting obscurities 'night after night'.

In Wilde's short story 'The Sphinx without a secret', the narrator's friend falls in love with a woman surrounded by an air of mystery, which he acknowledges to be a part of her attraction. The reason for this is never resolved. But at the end the question is

no longer the nature of the secret, but whether there was one at all. The narrator concludes from his friend's story:

> Lady Alroy was simply a woman with a mania for mystery. She took these rooms for the pleasure of going there with her veil down, and imagining she was a heroine. She had a passion for secrecy, but she herself was merely a Sphinx without a secret.[5]

As long as the Sphinx can maintain her illusion of posing a question and withholding an answer, of being other than she seems, she has the lover in her power: 'I wonder?', he continues to ask at the end. The appeal is in the illusion of a concealed true identity, and nothing separates the illusion which is an illusion from the illusion which is only the illusion of an illusion.

Dorian's love for Sybil dies when she ceases to be able to act. Fascinated initially by the thought of 'the wonderful soul that is hidden away in that little ivory body' (63), he is disillusioned by Sybil's own proclaimed acquiescence in this representation of herself as masking an identity off the stage:

> Before I knew you, acting was the one reality of my life. It was only in the theatre that I lived. I thought that it was all true. I was Rosalind one night, and Portia the other. . . . You came – oh, my beautiful love! and you freed my soul from prison. You taught me what reality really is. Tonight, for the first time in my life, I saw through the hollowness, the sham, the silliness of the empty pageant in which I had always played. Tonight, for the first time, I became conscious that the Romeo was hideous, and old, and painted, that the moonlight in the orchard was false, that the scenery was vulgar, and the words I had to speak were unreal, were not my words, were not what I wanted to say. You had brought me something higher, something of which all art is but a reflection.
>
> (98–9)

Sybil has discovered a language of authenticity, a real self and 'what reality really is', against which the theatrical world is now perceived as false. The stage's former reality is now no more than ugly old men masquerading as lovers. But the reality she finds in Dorian is that of a 'Prince Charming' who 'has not yet revealed his real name. I think it is quite romantic of him' (74). It is by making a new fiction of the world outside that Sybil can come to see the 'real' ugliness of her artistic world. But Sybil is now to Dorian

what the ageing actors are to her. Having transferred her attach-
ments from stage characters to himself, she performs 'like a
wooden doll' (97), as 'stereotyped' as the contemptible 'ordinary
women' of the nineteenth century: 'What are you now? A third-
rate actress with a pretty face' (100). The logic of self-discovery
compels her, as a Sybil speaking and acting in her own person, to
suicide: her new-found real identity is ended by Prince Charming's
abrupt rejection.

Sybil abandons the sexual, historical and imagistic mobility of
her artistic persona for the deadly third-rateness of finding a true,
consistent self. Dorian Gray, on the other hand, is introduced to an
identity of his own which is at the same time that of an artistic
image. The opening chapter of the novel brings together three
men – the artist, Basil Hallward, the dandy philosopher, Lord
Henry, and the subject himself – for a private view of the coming
into the world of the picture of Dorian Gray. Before Dorian sees
the finished portrait, in his state of 'just conscious boyhood' (103),
'unspotted from the world' (23), Lord Henry gives him a verbal
glimpse of possibilities hitherto unimagined:

> You have a wonderfully *beautiful* face, Mr Gray. . . . Ah! realize
> your *youth* while you have it. . . . Be always searching for *new*
> *sensations*. Be afraid of nothing. . . . A new Hedonism – that is
> what our century wants. You might be its visible symbol. With
> your *personality* there is nothing you could not do. The world
> belongs to you for a season. The moment I met you I saw that
> you were quite unconscious of what you really are, of what you
> really might be. There was so much in you that *charmed* me that
> I felt I must tell you something about yourself.
>
> (29–30; italics mine)

Beauty, youth, charm and the imperative to constant pleasures
will now be the terms which frame Dorian's identification of his
picture. Lord Henry's words supply a commentary which deter-
mines the way their subject sees a self of whose potential he was
previously, according to this representation, 'quite unconscious':
'His cheeks flushed for a moment with pleasure. A look of joy
came into his eyes, as if he had recognized himself for the first
time. . . . The sense of his own beauty came on him like a
revelation' (32).

But the very recognition of the portrait as an image of perfection
provokes a counter-movement from pleasure to fear. As a result

of Lord Henry's 'strange panegyric on youth' (33), Dorian comes
to imagine that

> there would be a day when his face would be wrinkled and
> wizen, his eyes dim and colourless, the grace of his figure
> broken and deformed. . . . He would become dreadful, hideous
> and uncouth.
> As he thought of it, a sharp pang of pain struck him through
> like a knife.

(33)

The words prefigure the end of the novel, where Dorian strikes
the portrait which has taken on the signs of his age and sins, and
dies himself. It is the absolute perfection of his image and the
pleasure of contemplating it which determine the supposition of a
possibly flawed image and the slide into the opposite emotion.
Beauty and youth are set from the start against the menace of their
decline, and pleasure is marked as necessarily ephemeral: the
world will belong to the perfect youth only 'for a season'. In
seeing himself in an image of perfect beauty, Dorian also sees that
image as potentially disfigured: the fulfilled idea suggests the risk
of its failing. Similarly, the 'pleasure' and 'joy' of that rapturous
recognition of a completed image of himself imply an inevitable
disappointment, that looker and image will not always be the
same.

At the very moment when Dorian Gray acquires an identity,
then, that identity is seen as both vulnerable and ambiguously
divided, between an image and a spectator of that image. But in
the Faustian pact that follows – 'If it were I who was to be always
young, and the picture to grow old! . . . I would give my soul for
that!' (33) – Dorian and the portrait change places. 'Life imitates
art', according to Wilde's critical dictum,[6] and Dorian can now
parade in person as Lord Henry's 'visible symbol' of the nine-
teenth century and Basil Hallward's artistic 'masterpiece', cate-
gorically removed from the vulgar realistic constraints of physical
deterioration or 'wooden' conformity to an ordinary type. Unlike
Sybil Vane, who fell from grace by assuming a personal identity
outside art, Dorian Gray finds his unique self in the form of an
idealized artistic representation.

The characteristics of Lord Henry's 'visible symbol' of the
modern age are not only those of the aesthetic philosopher's
dream boy. A preoccupation with beauty, youthfulness, charm

and the 'grandiose illusions' of Lord Henry's 'there is nothing you could not do' are also the terms in which Christopher Lasch censoriously defines the narcissistic personality type he associates with twentieth-century consumer society.[7] In one sense, then, *Dorian Gray* looks less like a late Victorian symbol than a prototype of something much more contemporary. Its hero is able to live out the fantasy of becoming as well as desiring an idealized image of himself in the form of a pleasure-seeking beauty. In his perfection, Dorian then comes to represent to others a fashionable model for emulation. He is invested with the originality of the ultimate *'arbiter elegantiarum'* (145):

> His mode of dressing, and the particular styles that from time to time he affected, had their marked influence on the young exquisites of the Mayfair balls and the Pall Mall club windows, who copied him in everything that he did, and tried to reproduce the accidental charm of his graceful, though to him only half-serious, fopperies.
>
> (144–5)

While remaining himself only 'half-serious' in his 'affected' styles, Dorian's symbolic force is unassailable in his embodiment of 'fashion, by which what is really fantastic becomes for a moment universal, and Dandyism, which . . . is an attempt to assert the absolute modernity of beauty' (144). He is both omnipotent and invulnerable, even to the extent that he can appeal to his youthful appearance to prove to her brother that he could not have been the 'Prince Charming' who caused the death of Sybil Vane eighteen years before. In his freedom from the realistic necessities of physical decline, Dorian is like a walking advertisement, living proof that youth and beauty can, after all, be eternal.

This implicit convergence of the ideals of advertising and aesthetics can be further suggested by the growing habit during this period of commissioning famous artists to design advertisements. The first and best-known of these, Millais's *Bubbles* (1886) was an ad for Pears' soap showing a beautiful curly-haired boy who might have been a prefiguring type for Dorian Gray himself.

A crucial aspect of Lord Henry's 'new Hedonism' is the perpetual quest for 'new sensations'. As in the fashion cycle, novelty is made a value in itself, and the immediacy of sensation exceeds in worth the old-fashioned virtue of restraint. 'One could never pay too high a price for any sensation', says Lord Henry (67) and

the economic wording points both to the connection between experiences and commodities as sources of gratification, and to a (new) focus on expenditure as opposed to accumulation.

The prescription for Dorian's hedonistic life style can be compared to a perceptible reorientation of economic theory at the end of the nineteenth century. Alfred Marshall's *Principles of Economics*, published in 1890 when the first version of *Dorian Gray* appeared, contains the following passage:

> The price which a person pays for a thing can never exceed, and seldom comes up to that which he would be willing to pay rather than go without it: so that the pleasure which he gets from its purchase generally exceeds that which he gives up in paying away its price; and he thus derives from the purchase a surplus of pleasure. The excess of the price which he would be willing to pay rather than go without the thing over that which he actually does pay, is the economic measure of this surplus pleasure, and may be called Consumers' Rent.[8]

The language implies a rational *homo economicus* soberly making his calculations on the basis of a fully quantifiable set of variables concerning the purchase contemplated. But Marshall none the less has recourse to a concept which seems by comparison with price or surplus value remarkably vague. 'Pleasure' is uneasily expressed as a precise arithmetical unit: what the consumer would pay minus what he does pay. The presupposition – that pleasure is conditional on the relative avoidance of spending – is a nineteenth-century one, but the focus on pleasure is new and unsettles the rationalistic structure of the exposition.

Marshall is cited in the O.E.D. *Supplement* as one of the first instances of 'consumer' used in its modern sense, and 'consumption' also makes its appearance at about the same time. Palgrave's *Dictionary of Political Economy* (1894) states that 'Consumers' Goods (or Consumption Goods) include all those desirable things which directly satisfy human needs and desires.' The dominance of the repeated 'desirable ... desires' reflects, as in Marshall, the gradual departure from a framework assuming circumscribed, measurable 'needs'. Etymologically, the word 'consumption' contains both these elements. In its basic sense of wastage or using up, the expenditure involved in consumption acquired all the dissolute connotations of Victorian 'spending': the throwing away of a finite and precious substance on a solitary

and debilitating pleasure. But the link with 'consummation', more obvious in the French *société de consommation*, points to a more sublimely sexual meaning and to the possible fulfilment of Palgrave's unlimited 'desires'.

It is this modern, excessive and pleasurable aspect which finds expression in the aesthetes' predilection for the adjective 'consummate'. This is parodied in a song of the early 1880s, 'My Aesthetic Love', which begins:

> She's utterly utter consummate too too!
> And feeds on the lily and old china blue,
> And with a sun flower she'll sit for an hour
> She's utterly utter consummate too too.[9]

The 'consummate' spectacle of self-enclosed perfection here taken in by the aesthete is doubled in the figure of the girl herself, who 'feeds on' or consumes the beautiful things caricatured as obvious indicators of the consciously aesthetic consumer lifestyle.

Lord Henry Wotton makes a similar contrast of economic principles by defining his own philosophy of pleasure against the concept of investment. The 'aim' of the new Hedonism 'was to be experience itself, and not the fruits of experience, sweet or bitter as they might be. . . . It was to teach man to concentrate himself upon the moments of a life that is itself but a moment' (146). This passage is close to one from Pater's 'Conclusion' to *The Renaissance*:

> Not the fruit of experience, but experience itself, is the end. A counted number of pulses only is given to us in a variegated, dramatic life. . . . What we have to do is to be for ever curiously testing new opinions and courting new impressions.[10]

As in Wilde, the argument is against a puritanical deferral of gratification, the fruit rather than the experience, and celebrates in its place the 'curiously testing' experiential-experimental openness to what is 'new' in the form of 'opinions' and 'impressions'. If life is only an 'interval' before the inevitability of death,

> our one chance lies in expanding that interval, in getting as many pulsations as possible into the given time. Only be sure that it is passion, that it does yield you this fruit of a quickened, multiplied consciousness.[11]

Now experience is represented as a 'fruit' or profit in itself: the

goal of an individual's 'interval' is the maximization of this pulsating profit, exactly as the rational entrepreneur might calculate the relative gains from possible investments. But the overt emphasis is on the aesthete as a consumer or recipient of impressions, not a producer: like an alert shopper, he must select what is 'choicer' in the forms or tones that surround him at any one moment.[12]

Lord Henry remakes Dorian as the advertiser markets his product. In representing his image to him as both the epitome of modern youth and beauty, 'the finest portrait of modern times' (32) and 'the real Dorian Gray' (35), he gives him an advertisement for himself, in relation to which Dorian is both the consumer and what he buys. He is taken over by words which impose on him an identity he will henceforth live as his own. But his very uniqueness is entirely derivative.

The portrait in which Dorian now claims to have 'recognized himself for the first time' (32) is already Basil Hallward's creation and one into which the artist says he has put 'too much of himself' (17). The 'real' Dorian who emerges from the scene of initiation is thus composed of the image of the artist and the words of the philosopher. He assumes as his own this identity born of disparate parents: the visual and the verbal, the imagistic and interpretative.

When image and slogans combined have sold Dorian the picture of himself as the modern ideal, he can sell his outdated 'soul' to the equally outdated devil, consigning the portrait of moral and physical decay to the attic. He exchanges a moral self for the unfettered freedom of the new hedonist, for whom 'insincerity' is 'merely a method by which we can multiply our personalities' (158): 'Eternal youth, infinite passion, pleasures subtle and secret, wild joy and wilder sins – he was to have all these things' (119). There is no limit to what Dorian can have, to the number of 'personalities' he can adopt, to the experiences he can sample. All poses, all personalities, are equal, circumscribed by neither moral nor numerical boundaries, and referrable to no state of authenticity from which they differ: 'Being natural', too, 'is simply a pose' (10).

After Lord Henry's words and his consequent identification with the portrait of himself as the perfection of youth, Dorian encounters a supplementary influence in the French novel lent him by the same friend. In it, he finds: 'a kind of prefiguring type of himself. And, indeed, the whole book seemed to him to contain

the story of his own life, written before he had lived it' (142). In his very appropriation of the book, making it his own and reading it as referring specifically to himself, Dorian thus relinquishes the uniqueness of a life which turns out to have been already written. The script is simply there for him to act out. 'Life imitates art' once again: the authenticity of personal experience only appears as such in light of previously existing representations which also, thereby, give the lie to the individuality they ostensibly uphold.

As a result of his reading, Dorian plunges into a renewed 'search' for sensations that would be at once new and delightful, and possess that element of strangeness that is so essential to romance' (147). Believing sometimes, like the hero of his novel, 'that the whole of history was merely the record of his own life' (160), he becomes an intellectual narcissist, seeking and reading his story everywhere from Imperial Rome to Renaissance Italy. Losing even the relative singleness of an identity which imitates another or is 'prefigured' in another, Dorian's grand aspirations, by identifying him with all the great men of history, reduce him to pure generality. Since he sees himself in everyone, his self can have no distinguishing features at all.

For all his advocacy in 'The soul of man under socialism' (1891) and elsewhere of a 'self-development' proper to each individual, Wilde could also maintain this contrary view, by which all that appears to mark off the unique 'personality' is merely a matter of secondary surfaces:

> Where we differ from each other is purely in accidentals: in dress, manner, tone of voice, religious opinions, personal appearance, tricks of habit and the like. The more one analyses people, the more all reasons for analysis disappear. Sooner or later one comes to that dreadful universal thing called human nature.[13]

It is this underlying sameness, not the 'secret' self, which is hidden beneath the surface of an individual personality. The scandal of the masquerade of individual poses or parts is that they hide nothing.

Lord Henry's objection to labels in the name of their potency is consistent with this structure. Since there is no individual before the mask or label which comes to identify him, the label, however arbitrary, is absolutely determining: there is no real self against which its truth or falsehood could be measured. It follows from

this, according to 'the philosophy of the superficial',[14] that 'it is only shallow people who do not judge by appearances' (29).

Dorian's literary tourism takes him not only into a history that mirrors himself, but along the paths of disparate intellectual interests – jewels, embroidery, Catholicism, music – without any connecting thread. Simply 'that curiosity about life which Lord Henry had first stirred in him . . . seemed to increase with gratification. The more he knew, the more he desired to know' (144). His researches follow the pattern laid down in the influential book; as he followed it by putting on multiple identities in his reading of history, so he follows it in his passionate consumption, or taking in, of objects and facts pertaining to each new subject. As he lost – and made – himself in taking on other personae, so

> he would often adopt certain modes of thought that he knew to be really alien to his nature, abandon himself to their subtle influences, and then, having, as it were, caught their colour and satisfied his intellectual curiosity, leave them.
>
> (147)

Dorian remains a blank canvas, a *tabula rasa* for intellectual impressions ever susceptible to, and never retaining the imprint of, what was previously marked upon it. Individual philosophies are treated like the rich or interesting objects Dorian accumulates, as temporary sources of pleasure to be given up, like cigarettes, when they have ceased to satisfy.

Nothing, then, marks a necessary terminus to Dorian's multiplication of pleasures and poses. He lives the dream life of the aesthetic consumer, culling momentary impressions and satisfactions from a world which withholds nothing and offers everything. His continual search for 'new sensations' involves treating the world as a source of subjective gratifications to be enjoyed and used up, and the novel includes many descriptions of interior settings which sumptuously answer to this. The opening is a case in point:

> From the corner of the divan of Persian saddle-bags where he was lying, smoking, as was his custom, innumerable cigarettes, Lord Henry Wotton could just catch the gleam of the honey-sweet and honey-coloured blossoms of a laburnum, whose tremulous branches seemed hardly able to bear the burden of a beauty so flame-like as theirs.
>
> (7)

The passage poses Wilde's 'art of lying' in a supinely synaesthetic atmosphere, with the aristocratic aesthete pleasurably and passively sucking in the manifold sensory stimulants that surround him. But the moment of Paterian perfection, of a 'flame-like' 'beauty' evanescently grasped, also resembles, in its luxurious fusion of 'Persian' exoticism and a tastefully cultivated English garden, a lavish description from a catalogue of interior decoration.

The juxtaposition of aestheticism and domestic consumption merges concerns which Wilde himself considered inseparable. Like John Ruskin and William Morris, he was an active and forthright campaigner for improvements in the artistic quality of home furnishings, regarding the education of taste in a public committed to the purchase of such goods as a worthy and attainable goal. In 'The soul of man under socialism', he claims that there has been a shift from the 'Great Exhibition of international vulgarity', so that 'it is now almost impossible to enter any modern house without seeing some recognition of good taste, some recognition of the value of lovely surroundings, some sign of appreciation of beauty'.[15] This 'revolution' is owing, however, not to a grass-roots movement on the part of consumers, but

> to the fact that the craftsmen of things so appreciated the pleasure of making what was beautiful, and woke to such a vivid consciousness of the hideousness and vulgarity of what the public had previously wanted, that they simply starved the public out. . . . However they may object to it, people must nowadays have something charming in their surroundings. Fortunately for them, their assumption of authority in these art-matters came to entire grief.[16]

As well as taking for granted an absolute standard of beauty, Wilde assumes arbitrarily that the earlier taste for the mass-produced signs of 'International Vulgarity' was the public's own, whereas the present more 'civilised' taste was forcibly imposed by the lack of available alternatives. Ironically, in welcoming what he perceives as a return to authentic, artisanal forms of production, he valorizes the workings of the large-scale marketing system he is implicitly opposing. In a lecture on 'House Decoration' given in America in 1882, Wilde had said:

> We should see more of the workman than we do. We should not

be content to have the salesman stand between us – the salesman who knows nothing of what he is selling save that he is charging a great deal too much for it.[17]

Here Wilde explicitly censures the middleman, and the infiltration of marketing into craftsmanship. But in the passage quoted above, he effectively congratulates the craftsman for having succeeded in establishing a uniform monopoly, for imposing a certain kind of product on a public left with no other choice. It was upon just such a creation of previously non-existent demands and preferences that the new mass-marketing practices depended.

Wilde's partisanship and dogmatism here are quite unlike the philosophy articulated in *Dorian Gray* and elsewhere. Granting a supreme value to novelty and number, rather than to some innate quality, precludes any fixed criterion on which to base the evaluation of sensations, or to distinguish 'artistic' from other sensations. But Wilde himself would regard the possibility of such a contradiction as irrelevant. He can write a soberly academic piece praising historical accuracy in productions of Shakespeare and then at the conclusion suddenly change tack:

Not that I agree with everything that I have said in this essay. There is much with which I entirely disagree. The essay simply represents an artistic standpoint, and in aesthetic criticism attitude is everything. For in art there is no such thing as a universal truth. A Truth in art is that whose contradictory is also true.[18]

Different artistic standpoints can be differently valid, then, or differently invalid; and both sides of this must apply, paradoxically, to the one which claims the self-evidence of a single form of taste. Only in the realist world of 'the man who could call a spade a spade' (215) does language claim to correspond to a truth it does not make, rather than to aim, like stage props, at 'the illusion of truth'. But perhaps Wilde is unwittingly, or wittily, consistent in his accidental endorsement in the lecture of the advertiser's philosophy of the value-free creation of new desires: it was also the philosophy of the aesthetes' New Hedonism.

It is in this mode of provocative non-commitment that the Preface to *Dorian Gray* deals summarily with the question of art and ethics:

There is no such thing as a moral or an immoral book. Books are

well written or badly written. That is all.
 No artist has ethical sympathies. An ethical sympathy in an
artist is an unpardonable mannerism of style.

(5)

Wilde teasingly raises only to repudiate the possibility of taking
the novel as a morality tale. Given that it includes a paraphrase of
the contents of a 'poisonous book' (140), which is itself partly
about the 'strange manners of poisoning' known in the Renais-
sance (163), the novel's own critical condemnation as a 'poisonous
book' would seem to involve the kind of partial reading Wilde
caricatured in another of the prefatory maxims: 'It is the spectator,
and not life, that art really mirrors' (6).[19] In any case, the fatal
ending of the novel could equally well be taken to show its
morally uplifting, admonitory effect. But as Roger B. Henkle has
argued, the narrative of crime and punishment is a debunking,
not a confirmation, of 'the Puritan notion of moral consequence.
. . . Wilde is seeking to dispose of this paradigm by mockingly
reconstructing it, and then throwing it by its own weight'.[20]
 Dorian Gray does not in fact fall straightforwardly into any
generic category, and the narrative of a lost soul, sin and eventual
repentance is only one of innumerable different forms and styles
contained within it. It is partly a decadent psychological novel like
J.-K. Huysmans' *A Rebours* (1884), to which obvious allusion is
made in the account of the 'poisonous book'; partly, also, a novel
about the milieu of art, like Zola's *L'Oeuvre* (1885). As Kerry
Powell has documented, it utilizes many features of a genre
popular at the time which she summarizes under the head of
'magic-picture realism'.[21] In addition, there are scenes of drawing-
room comedy anticipating the plays Wilde would write in sub-
sequent years. Polite conversations and repartee, descriptions of
high-class interior décor, scenes of vulgar dissipation, moments of
Gothic horror, epigrammatic disquisitions on art and life, cata-
logues of *objets* and nuggets of information, farcical interludes like
the 'peppering beaters' incident: all these modes are there, alter-
nating and overlapping in no particular order and with no
obvious approach to the appearance of either a conventional linear
narrative in the mode of realism, or a consistent symbolic line in
the mode of allegory.
 In that it incorporates and alludes to many disparate levels and
styles of writing, *Dorian Gray* effectively sets them all at a distance.

It becomes like a sample catalogue of literary forms which by arbitrary juxtaposition lose all connection with the notion of a unifying theme or action and its corresponding genre. Suggesting no privileged forms in terms of which to interpret the others, the novel reduces the morality plot to pastiche: 'medieval emotions are out-of-date' (90). Even within this plot, Dorian dies not because of the unspecified sins he has committed but because, in slashing the image of his other self, subject to age and ethical laws, he has implicitly accepted its different order, looking upon it as a threat to be eliminated.

Far from being poisonous, or an antidote to poison, the morality plot functions more like a parody of the style of the 'sensational' novels and tabloid newspapers of the period, with their regular presentation of the scandals of high life – murder, divorce, poison – for the public's ready consumption. When Lord Henry learns of Dorian's unusual parentage, involving a hushed-up aristocratic story of paternal jealousy and a husband's murder, he pronounces him, like a placard headline, 'son of Love and Death' (45):

> Crudely as it had been told to him, [the story] had yet stirred him by its suggestion of a strong, almost modern romance. A beautiful woman risking everything for a mad passion. A few wild weeks of happiness cut short by a hideous, treacherous crime. Months of voiceless agony, and then a child born in pain. The mother snatched away by death, the boy left to solitude and the tyranny of an old and loveless man.

The story is resumed in the language of popular journalism, with which Lord Henry shows himself to be aesthetically complicit. Far from detracting from Dorian's image, 'it was an interesting background. It posed the lad, made him more perfect as it were. Behind every exquisite thing that existed, there was something tragic' (44). And right at the beginning, the novel takes its frame of reference from a tabloid scandal by introducing Basil Hallward as the artist 'whose sudden disappearance some years ago caused, at the time, such public excitement, and gave rise to so many strange conjectures' (7).

'Sensations' in *Dorian Gray* are not confined to an isolated sphere of high art. As 'the type which the age has been searching for', Dorian becomes something more than a pretty boy: he is sensational in the double sense of a newsworthy star and an aesthetic stimulus. In the same way, Dorian's experiencing of

endlessly new sensations runs the gamut from the most 'vulgar' to the most aesthetically refined.

Dorian Gray is a plug for aestheticism at the start of the decade that would see the movement reach the height of its public fashion. It is also, and by the same token, a catalogue of the forms of identification of the ideal consumer as dandy: a receptacle and bearer of sensations, poser and posed, with no consistent identity, no moral self. In the novel's terms, as we have seen, Sybil Vane's 'tragedy' is not so much that Dorian deserts her, as that she casts off the role of actress in the belief that she has found a fixed identity beyond her various theatrical parts.

The narcissistic, pleasure-seeking dandy personifies a fantasy in which the ascetic bourgeois individual has ceased to be. 'Pleasure', declares Lord Henry, 'is the only thing worth having a theory about' (89), and his question, if not the uniqueness, was also implicit, as we have seen, in the economic language of the time. But the fullest interrogation of the nature of pleasure in its relation to the sexual and ethical determinations of the individual subject was to begin later in the decade with the extended researches of a certain Viennese neurologist. Lord Henry is himself not unlike an early version of the psychoanalyst, with his study of 'the curious hard logic of passion' in which 'he had begun by vivisecting himself, as he had ended by vivisecting others' (66); and Dorian Gray learns 'to wonder at the shallow psychology of those who conceive of the Ego in man as a thing simple, permanent, reliable, and of one essence' (159).

Dorian Gray posits a subject uncannily split, with the old-fashioned moral self there as a possible but not constitutive threat to what is otherwise an existence devoted purely to self-gratification. Freud's theory would bring that menace to the fore. As with Lord Henry's 'New Hedonism', desire in Freud is endlessly unfulfilled, but its fulfilment is blocked off from the outset by the moral and sexual regime of identification which determines both the loss of imaginary satisfaction and the ceaselessly renewed quest for its recovery. In this light, the magical aspect of _Dorian Gray_ becomes crucial: it is only because Dorian can suspend the conditions of reality which would otherwise limit his narcissistic pleasures that he can thrive in the perfect freedom of indulgence.

The fantasy of lawlessness thus operates as a powerful, if not sensational, source of pleasure, one which unites the interests of

aesthete and consumer alike. In final support for such a connection, I can do no better than cite again from an authority which Wilde described as 'that book which has had such strange influence over my life'.[22]

> Art comes to you proposing frankly to give nothing but the highest quality to your moments as they pass, and simply for those moments' sake.[23]

Art's representative offers his product with all the pseudo-artlessness of the professional salesman, including a personal touch – 'Art comes to you' – and 'proposing frankly' its superior merits: 'nothing but the highest quality'. With his posture of one-to-one sincerity and his special recommendation, the author might have been writing a textbook example of advertising copy rather than an original aesthetic statement. But perhaps, after all, there is little to choose between Lord Henry's puff for cigarettes and Pater's endorsement of art. The final sentence of the 'Conclusion' to *The Renaissance* is surely the last word in advertising technique. In its forceful promotion of the momentary personal pleasures promised by its object, it could be said to mark the beginning of modern consumer culture.

Chapter 3

'But she could have been reading Lady Chatterley'
The obscene side of the canon

The final volume of *The Oxford Anthology of English Literature,
Modern British Literature*, includes a long extract – nine pages,
almost the whole – from Lawrence's essay 'Pornography and
obscenity'. This minor fact may seem quite unremarkable. It could
be cited as one of many pieces of evidence for the contemporary
stature of Lawrence, the kind of writer whose auxiliary publica-
tions are considered canonical too; and the essay's subject-matter
might be seen as an indirect allusion to the particularly violent
curbs his works faced and then overcame before he attained his
deserved place (among others, *The Rainbow* and *Lady Chatterley's
Lover* were subject to banning following their publication). The
editors, John Hollander and Frank Kermode, draw attention to
this latter aspect in their introduction to the piece, beginning with
the statement that 'Lawrence had first-hand experience of those
he called "the censor-morons"', and then providing a brief
history of the fortunes of *Lady Chatterley*.[1] In light of the triumphant
ending, Lawrence's struggle seems all the more heroic, retro-
spectively a sign of popular philistinism prior to the due assign-
ment of his deserved literary status.

It would be possible to proceed from this point to the common
allegation that the merit of works in the canon is largely a function
of their inclusion, rather than the other way around. But the
exaltation of 'Pornography and obscenity' suggests a somewhat
more forceful possibility: that the establishment of literary value
might be dependent on a corresponding exclusion not just of a
great remainder of works classified as merely indifferent –
unexceptional and unexceptionable – but of a category of the
obscene, with the recommended values of literature functioning
only so far as they can be defined as the obverse of the vilified

values of obscenity. It is not that Lawrence happened to write a rather good piece on a subject which he had all too much reason to have thought about long and hard, but that the very formation of this canon involves its active differentiation from what is defined as pornographic or obscene. From this point of view, the inclusion within the canon itself of a piece which is expressly concerned with the distinguishing of literary values from pornography and obscenity has a perverse and revealing logic. This may not be unrelated to the fact that out of the 679 pages of text in the Oxford anthology, published in 1973, precisely two contain writing by women (Edith Sitwell and Stevie Smith, a poem apiece).

'WRAGG IS IN CUSTODY'

Before turning to Lawrence and *Lady Chatterley*, a piece of pre-liminary evidence will set the scene for the preoccupations of the trial:

> 'A shocking child murder has just been committed at Notting-ham. A girl named Wragg left the workhouse there on Saturday morning with her young illegitimate child. The child was soon afterwards found dead on Mapperly Hills, having been stran-gled. Wragg is in custody.'[2]

This extract from Arnold's 'The function of criticism at the present time' (1864) is a 'paragraph on which I stumbled in a newspaper', quoted verbatim. In its new context, it serves him as a graphic illustration of what is wrong with England, following the scorn-ful citation of speeches by two men who represent the 'exuberant self-satisfaction' of the English. Arnold comments upon the news-paper report:

> Nothing but that; but, in juxtaposition with the absolute eulogies of Sir Charles Adderley and Mr Roebuck, how eloquent, how suggestive are those few lines! 'Our old Anglo-Saxon breed, the best in the whole world!' – how much that is harsh and ill-favoured there is in the best! *Wragg*! If we are to talk of ideal perfection, of 'the best in the whole world', has any one reflected what a touch of grossness in our race, what an original shortcoming in the more delicate spiritual perceptions, is shown by the natural growth among us of such hideous names – Higginbottom, Stiggins, Bugg! In Ionia and Attica they were

luckier in this respect than 'the best race in the world'; by the Ilissus there was no Wragg, poor thing!³

By the Ilissus, there were reputedly quite a few abandoned babies; but it is not this which preoccupies Arnold. His citation seems at first as if it may lead to a reflection on the particular moral condition of nineteenth-century England and its fallen women. But England suffers from 'an original shortcoming', not a contingent one, manifest in the irrefutably patent evidence of its 'hideous names'. Wragg's tragedy is in her name, in its blatant exhibition of a peculiarly English combination of a 'grossness' at once linguistic and natural. Something has been lost, and irretrievably, constitutively: the sound of the words of Ancient Greece is the standard of comparison for Victorian England, which can at this point it seems never, by definition, be remedied (its shortcomings are its nature).

'Wragg is in custody' thus takes on the function of a kind of anti-poetic touchstone or refrain, to be muttered as a token of the otherwise unspeakable qualities of the modern English:

> And 'our unrivalled happiness'; – what an element of grimness, bareness, and hideousness mixes with it and blurs it; the workhouse, the dismal Mapperly Hills, – how dismal those who have seen them will remember; the gloom, the smoke, the cold, the strangled illegitimate child!. . . . And the final touch, – short, bleak and inhuman: *Wragg is in custody.* The sex lost in the confusion of our unrivalled happiness; or (shall I say?) the superfluous Christian name lopped off by the straightforward vigour of our old Anglo-Saxon breed! There is profit for the spirit in such contrasts as this; criticism serves the cause of perfection by establishing them. . . . Mr Roebuck will have a poor opinion of an adversary who replies to his defiant songs of triumph only by murmuring under his breath, *Wragg is in custody*; but no other way will these songs of triumph be induced gradually to moderate themselves, to get rid of what in them is excessive and offensive, and to fall into a softer and truer key.⁴

The very economy of the phrase 'Wragg is in custody', which might have been taken as an abstention from superfluous commentary, becomes 'the final touch, – short, bleak and inhuman', 'bleak' picking up on the 'gloom' of the hills outside Nottingham

which seem already to have determined the atmosphere of the events of which they are doomed to be the setting. The lack of Wragg's first name is taken as a violation ('lopped off'), denying her the dignity of the marker of a fragile femininity which might have mitigated her unredeemable contemporary crudeness. It is the very unacceptability of the phrase 'Wragg is in custody' which makes it, for Arnold's purposes, repeatable, endowed with a function of negative education symmetrically opposite to that of the consoling 'touchstone' lines of good poetry he later evokes in 'The study of poetry'.[5]

THE WOMAN ON TRIAL

The sensationalistic potential of the newspaper report – a murder, a trial and behind them a story of poverty and sexual shame – serves Arnold indirectly as a contrast with genuine literary values, and the place of Wragg in Arnold's canonical essay may stand as an emblem for the peculiar association of degraded women, degraded language and degraded England that seems to have manifested itself time and again in the history of literary trials. But, in fact, when the first proposal in the English parliament for a law on obscene publications was made in 1857, a few years before Arnold's essay, its advocate, Lord Campbell, was at pains to ward off the fear that his proposed legislation might be intended to apply to anything published as serious literature. At one point during the debates on the bill, he produced a copy of Dumas's novel *La Dame aux camélias* in the English translation, declaring that although he disapproved of it himself, 'it was only from the force of public opinion and improved taste that the circulation of such works could be put a stop to'.[6] The subsequent history of obscenity trials and legislation was to prove him wrong: in future years, both literature and the lady were to be pursued by the 'force' of law. For it is as though the ambivalent status of those books hovering uncertainly on what came to be defined as a crucial boundary between 'literature' and 'obscenity' were derived in some indissociable way from the dubious figure of a woman and her sexual character. Situated on the verge between two equally untenable verdicts, depravity or respectability, she stands in for the book, a surrogate object of attack or defence. This concern in turn seems inseparable from the wider issues of

cultural value which the book and the trial are called upon to represent and to adjudicate.

Arnold's essay was written almost a century before the trial in 1960 of *Lady Chatterley's Lover*, the novel by Lawrence that had been banned in England since its first publication (from Italy) in 1928 (and only just freed in the United States, in two trials in 1959). Despite their geographical and nominal affinities, the case involving the Nottinghamshire writer and the Chatterley seat in Wragby seems a far cry from the Victorian gloom of 'Wragg is in custody', representing a victory for literary and sexual enlightenment of a kind which would have seemed entirely unthinkable in relation to Arnold's concerns for the moderation of the 'excessive and offensive' and the inculcation in its place of 'a softer and truer key'.[7] If the crime of the unmarried and unnatural, murdering mother stands as a cause for outraged lament against the condition of England and its language, Lady Chatterley seems to represent a moral victory for modern literature and modern attitudes to sex. Against the obviousness or the evidence of this story, I want rather to suggest that the 1960 trial and the understanding of Lawrence's work which surrounds it reveal some surprising continuities in the harnessing together of issues of language, sexuality and morality in English cultural criticism.

THE TRIAL OF LADY CHATTERLEY

The 1960 trial was a test case, following in the wake of the passing of new legislation. The Obscene Publications Act of 1959 added a supplementary criterion for cases considering whether a book (or some other publication) should be banned on the grounds of its obscene content. Henceforth, the verdict of obscenity – defined, in a phrase which dated back to Sir Alexander Cockburn's 1868 amendment to the Campbell Act, as the 'tendency to deprave and corrupt' – might be overridden by the consideration of 'public good'. The official formulation in the 1959 Act is as follows:

> A person shall not be convicted of an offence against Section 2 [the section referring to obscenity] if it is proved that publication of the article in question is justified as being for the public good on the ground that it is in the interests of science, literature, art, or learning, or of other objects of general concern.[8]

What this meant in the case of *Lady Chatterley's Lover* was that if

the defence could show that the book was of intrinsic literary merit, then it would not matter if it was obscene or not, literary merit being considered 'for the public good'. This the defence did with astonishing success. It brought on a devastating array of 'experts', professional people ranging from literary critics such as Raymond Williams and Graham Hough to teachers, social workers, a Church of England bishop and well-known writers such as C. Day Lewis and E.M. Forster. In all there were 35 witnesses and 36 more who were not called upon.

This parade of 'respectable' people speaking on behalf of a notoriously 'dirty book' provided a rare media spectacle, in which the newspapers could tantalize or shock their 'public' with reported citations or interpretations from the work which no one was yet authorized to buy. In this context, it is significant that one of the most persistent side issues to emerge was the question of its likely readership. The trial had been instigated when Penguin Books, in the light of the new Act, declared their intention to publish the banned book at the low price of three shillings and sixpence. This was consistent with Penguin's declared policy at the time of its founding in the 1930s: cheapness of cover price to reach a working-class readership. The defence lawyer makes explicit reference to this in his opening speech: 'The next year he [Allen Lane] formed this company, Penguin Books Limited, to publish good books at the price of ten cigarettes.'⁹ The concern of the prosecution is not just that the book might be published but that it might be both cheap and accessible; and here it is not only workers, the presumed purchasers of packets of ten cigarettes, but also women, who are seen as either dangerous or endangered potential readers.

Near the beginning of the trial, the chief prosecution lawyer, Mr Griffith-Jones, asked: 'Is it a book that you would even wish your wife or your servants to read?'¹⁰ Far from being taken as the rhetorical question which it was presumably intended to be, this question provoked laughter from the jury, 'and may', C.H. Rolph remarks, 'have been the first nail in the prosecution's coffin'. The question took on a kind of synecdochical status in cultural mythology for the significance of the trial as a whole, standing for the way that it seemed to have marked a turning point in British culture that had already taken place. For Mr Griffith-Jones seemed to be appealing to a world that was no longer there – a world in which it was possible to invoke a homogeneous 'we' consisting of

middle- or upper-class Englishmen with servants and wives, from whom all dangerous reading matter should rightfully be kept away. Griffith-Jones's question backfired because it was taken to reveal the anachronism of his case against *Lady Chatterley*. Postwar Britain no longer appeared to contain even a significant proportion of middle-class households with living-in servants; and although many middle-class men no doubt had wives, it was not self-evident, as the question required, that their reading should be vetted by their husbands.

In a fascinating way, these specifications by age, sex and class re-enact variations and hesitations in the history of the legal definitions of obscenity in relation to readers' susceptibility. Campbell's formulation in 1857 wavered between on the one hand an echo of Socrates' accusers in the mention of a particular vulnerable group, and on the other an appeal to a general concept of mental discipline:

> The measure was intended to apply exclusively to works written for the single purpose of corrupting the morals of youth, and of a nature calculated to shock the common feelings of decency in any well-regulated mind.[11]

Cockburn's modification of this in 1868 omitted the youth, and made a number of other significant changes:

> I think the test of obscenity is this, whether the tendency of the matter charged with obscenity is to deprave and corrupt those whose minds are open to such immoral influences and into whose hands a publication of this sort may fall.[12]

The tone is now more ominous, 'deprave and corrupt' implying far more serious and long-term consequences than a transient upset to ordinary 'feelings of decency'. Cockburn has shifted the emphasis from exclusive intention to likely effect, and restated the general psychological formulation in terms not of personal and transient shock to the average individual, but of immoral influence to a group marked off as especially susceptible. And crucially, he has added a clause which draws in the conditions of distribution. The combination supplies the first legitimation for discriminations in terms of price which could clearly bear a relation to class. In *To the Pure . . .* , published in 1929, Morris Ernst and William Seagle called the effects of this structure 'the aristocracy of "smut"', in other words the relative invulnerability to prosecution of books

with high prices and discreet marketing methods: 'ordinarily the publisher, if he confines his advertising to "Physicians, Clergymen, and Lawyers," has not much to fear'.[13]

The wording of the 1959 Act recapitulates Cockburn with the same distinctive yoking of gothic psychology and the sociology of consumption:

> An article shall be deemed obscene if its effect or (where the article comprises two or more distinct items) the effect of any one of its items is, if taken as a whole, such as to tend to deprave and corrupt persons who are likely, having regard to all relevant circumstances, to read, see or hear the matter contained or embodied in it.[14]

There was thus a legal basis not only to the reference in the *Lady Chatterley* trial to particular vulnerable groups but also to the concern about 'mass' readership which was never openly named. And interestingly, interrogating lawyers hark back to Campbell's preoccupation with juvenile welfare: to Griffith-Jones's wives and servants were added the differently used category of children, or at least adolescents. Witnesses are habitually asked whether they have children and whether they would mind them coming across the book, the implication being that it must be all right (or all wrong) if these experts feel happy about their own offspring reading it. Whereas with the wives and servants there is a joke in the idea that the gentlemen would take it upon themselves to determine their reading matter, with children the point seems to be taken as reasonable that any responsible parent would withhold literature that was likely to do them harm.

The 'wives and servants' conjunction is particularly telling in regard to this novel, whose story concerns the romance of a 'lady' with a man of a lower social class: her husband's gamekeeper. There is thus a strange repetition in the worry about who might read the book, as if it were implicitly being acknowledged that it might be taken as a kind of recipe or invitation for women and servants, ladies and gamekeepers, not to keep their social and sexual places. Against this, the defence argues for the validity and worth of 'human relationships', between the sexes and between different social classes, and not excluding a sexuality in relation to which the woman too is now to be regarded as having needs and desires. The defence thus takes the line that far from being pornographic or obscene, *Lady Chatterley* is in fact highly moral,

and not least because it implicitly advocates ideals whose validity has now come to be acknowledged in the mid-twentieth century, the age of social and sexual enlightenment. One of the witnesses, an educational psychologist named James Hemming, puts it like this: 'It is now well recognised that for young people to grow up and marry with a prudish and ashamed attitude towards sex is positively harmful. *Lady Chatterley's Lover* presents sex as it should be presented.'[15] At the same time (and here literature is serving the same social function as it does for Matthew Arnold), because the generality of culture is debased, it is all the more crucial for the true values the novel teaches to be made available. Hemming uses the language of scientific medicine when he describes *Lady Chatterley* as a potential 'antidote' to the prevailing 'shallow and corrupting values with regard to sex and the relationships between the sexes'.[16]

In this regard, it is interesting that the defence witnesses in fact tend to make their case by picking up exactly the same terms of argument as those used to damn *Lady Chatterley's Lover*. The prosecution rests its case on the idea that this is a dirty book, likely to 'deprave and corrupt' the minds of those who read it. The defence does not say that that is an inappropriate way of putting the matter, that it might be difficult or futile to determine the difference between a dirty book and a non-dirty book. Instead, it claims that *Lady Chatterley's Lover* is an exceptionally clean or wholesome book. Where the prosecution is saying that it will have a deleterious effect on public and private morality, the defence says not only that it won't but that it will have an effect that is positively salutary. In other words, the defence too adopts the categories of clean and dirty, wholesome and unwholesome, moral and immoral.

This emerges in relation to two particular features of the novel, the aspects with which the trial seems to be most preoccupied. The first is the question of what are euphemistically referred to throughout as 'the four-letter words', generally to be located in 'purple passages' and in the context of 'bouts'. The words that particularly concern the prosecution are 'fuck' and 'cunt'; some of the funniest moments in the trial occur when the prosecution lawyer tries reading out passages which contain these written in Lawrence's transcription of the Nottinghamshire dialect that Mellors, the gamekeeper, would have spoken. The intention of the lawyer here is to demonstrate – it is supposed to need no further

argument than the mere showing – how filthy the book quite clearly is. The defence's response is not simply to disagree with the 'touchstone' criterion (to hear or to see is enough to damn). Instead, a definite case is made in relation to the positive virtues of these words: Lawrence was trying to purify, to clean up, the language, by getting back to the original unsullied significance of the words which modern culture has debased.

Richard Hoggart for instance, argues as follows when he is in the witness box:

> Fifty yards from this Court this morning I heard a man say 'fuck' three times as he passed me. He was speaking to himself and he said 'fuck it, fuck it, fuck it' as he went past. If you have worked on a building site, as I have, you will find they recur over and over again. The man I heard this morning and the men on building sites use the words as words of contempt, and one of the things Lawrence found most worrying was that the word for this important relationship had become a word of vile abuse. So one would say 'fuck you' to a man, although the thing has totally lost its meaning; it has become simply derision, and in this sense he wanted to re-establish the meaning of it, the proper use of it.[17]

An entire theory of linguistic history and sexuality is contained in this. Like Arnold, Hoggart sets some store by the repetition of an obnoxious phrase as a kind of negative incantation, overhearing this thrice muttered curse. But the word 'fuck' is not, for Hoggart, 'vile' or abusive in itself: it has become so by being severed from its original sexual meaning. The problem is not that the word names sex, but that it does not: and 'this important relationship' has suffered too, by implication, since the word for it has been turned to other ends, to the point that 'the thing has totally lost its meaning'. Sexual and linguistic faults and proprieties are inseparable; the 'proper' employment of the one has to be matched by that of the other.

It is significant too that what Hoggart says here is entirely consonant with pronouncements that Lawrence made himself. More than most novelists, Lawrence was given to expressing his opinions on matters of art, sex, society, morality and language – all the matters which are supposed to be under consideration in the trial of Lady Chatterley. In 'Pornography and obscenity', for instance, which was written in 1929 just after the thwarted publication of Lady Chatterley's Lover, he states:

Pornography is the attempt to insult sex, to do dirt on it. This is unpardonable. Take the very lowest instance, the picture postcard sold under hand, by the underworld, in most cities. What I have seen of them has been of an ugliness to make you cry. The insult to the human body, the insult to a vital human relationship! Ugly and cheap they make the human nudity, ugly and degraded they make the sexual act, trivial and cheap and nasty. . . .

It is the same with the dirty limericks that people tell after dinner, or the dirty stories one hears commercial travellers telling each other in a smoke-room. Occasionally there is a really funny one, that redeems a great deal. But usually they are just ugly and repellent, and the so-called 'humour' is just a trick of doing dirt on sex.[18]

As in Hoggart's statement, and in a different way as with Arnold's desperate contrast between Attic Greece and the smoke of the Mapperly Hills, an original purity of language has been sullied. Sex itself, 'a vital human relationship', has been subject to 'insult', and the 'cheap and nasty' urban commodity epitomizes 'the very lowest instance' of a degradation that is indicated by its exclamatory opposition to what it is not.

In Arnold's commentary on Wragg, the girl's sins or misfortunes are displaced by the focus on the offensiveness of her name, which is found guilty in its own right of the crimes and abuses perpetrated by or on its bearer. In the case of the *Lady Chatterley* trial, however, it is the morality of the woman herself, fictional in this instance, which comes to stand in for the whole question of the book's merits or crimes. Lady Chatterley, like Wragg, is herself in custody. This second feature of the prosecution's attack is closely related to the focus on linguistic propriety. Was she or was she not justified in her adultery with the gamekeeper? As with the question of dirty language, the defence witnesses do not refuse to acknowledge the relevance of this issue. Instead, they provide the symmetrically opposite case, arguing that Constance Chatterley's conduct was not only not immoral, but as moral as could be. And there are several grounds for their saying this.

In the terms of the novel itself, Constance Chatterley is rather an unusual adultress, since her husband is physically incapable of sex (he was mutilated in the war) and has suggested at various

times that she might like to have a child, which would clearly not be his biologically.[19] The defence's argument is made sometimes in terms of 'a woman's natural desires', as when Cecil Day Lewis replies to Griffith-Jones's interrogation by saying, in the normative language of sexology: 'I think it is in her nature because she is an averagely sexed woman.'[20] But there is no suggestion that indiscriminate or non-commital sexual involvements might be acceptable. Richard Hoggart, for instance, is moved to revive by negation the spectre of Victorian sexual grime: 'If it had simply been a [sic] case that her husband was impotent and she wanted sex, she could have, and would have, had sex in every hedge and ditch round Wragby.'[21] The case is also made on the grounds of the sanctity of marriage and the indispensability to this of a sexual relationship. According to this argument, Constance's marriage to Lord Chatterley is effectively null and void, not an issue, because it cannot include sex. The real marital relationship of the novel is that of Constance and Oliver, who are working their way towards the complete union that is marriage in the proper, spiritual sense. In the words this time of no less qualified a judge in matters theological than the Bishop of Woolwich, 'what Lawrence is trying to do is to portray the sex relationship as something essentially sacred'.[22]

Here again, this defence in fact accords with Lawrence's own published view of the matter. In 1930, following what was already a complicated history of the vicissitudes of the novel's publications and piratings, he wrote a piece called 'A propos of *Lady Chatterley's Lover*' in which – among many other things – he declared that the greatest contribution made by Christianity to western civilization had been the invention of matrimony. Defence witnesses had a gift in being able to refer to this, which sounds so unlike the image of Lawrence the sex-obsessed pornographer which they are at pains to contradict. Lawrence also states here, as though giving Arnold's strictures about Wragg's sexless English name a more virile revision: 'An England that has lost its sex seems to me nothing to feel very hopeful about.'[23] (A later passage in the essay stresses the virtues of 'the phallic religion', and it is fortunate for the defence that Mr Griffith-Jones does not pick this up.)

There is thus an unexpected complicity in the cases brought by the two sides of the trial. Both sides are against dirt, against what they are calling obscenity. Lawrence can be defended on the grounds that his writing is not dirty at all – neither in the words he

uses, nor in the forms of life that he advocates. He is in fact more wholesome than his detractors, who make of sex a 'dirty secret', whereas modern society recognizes that it does not have to be, and indeed should not be. The respectable qualifications of the defence indicate to all the world that this is a matter not of gutter literature, but rather of purity itself, a higher form of art precisely because it is restoring the importance of sexuality in human marriage, as the highest form of human 'communion' (another word which, like 'sacred', brings together sexual and religious experience).

A WOMAN'S LOVE

The way in which the *Lady Chatterley* trial was regarded as an indicator of changes in social attitudes to sex at the beginning of the 1960s was linked, as we have seen, to ideas of progressive cultural enlightenment. In this connection, it makes perfect sense that the 'test case' novelist should have been Lawrence, whose advocates in less manifestly legal spheres had presented his work as central to that understanding of the problems of modern English culture which a literary education might play a useful part in disseminating. In particular, F.R. Leavis chose Lawrence as the sole twentieth-century writer deserving to be tacked on to the 'great tradition' of English novels combining literary merit with social criticism: in 1955 he had written a lengthy study called laconically *D.H. Lawrence: Novelist*. This text is instructive in that it shows the solidarity between the values the experts, both literary and non-literary by profession, saw in *Lady Chatterley*, and those which were being claimed for Lawrence more generally as the representative of literature and its social value.

Leavis himself pointedly refused to stand as a witness for the defence in the *Lady Chatterley* trial. His reasons were made evident in a piece called 'The new orthodoxy' which he wrote for *The Spectator* on the publication as a Penguin Special of Rolph's transcript of the trial shortly after it. For one thing, the novel was not one he considered representative of Lawrence's art (he had barely mentioned it in his book): '*Lady Chatterley's Lover*, then – it is important that this obvious enough truth should be asserted – is a bad novel.'[24] More generally, he distrusted the facile switch of allegiances on the part of some who had never been eager to come forward as Lawrence's defenders when Leavis was attempting to

make the case for him in criticism, and saw their case as a transposition of his own to the wrong object: 'Reading the testimonies now printed in the Penguin Special, I couldn't help feeling that I had a heavy degree of responsibility. It gave me a sense of guilt when I saw those formulations, which were so familiar to me, applied to *Lady Chatterley's Lover*, to which I (explicitly) did not apply them.'[25] Leavis thus belatedly enters the litigation, protesting 'guilt' by multiple proxy, and therefore also making himself 'responsible' for the defence's success. And ironically, the absence of Leavis in person from the trial does highlight the degree to which the defence of Lawrence as a great writer was conducted in terms compatible with, if not directly derived from, his own.

We have observed how the defenders of *Lady Chatterley's Lover* take up the terms of cleanliness and social wholesomeness which are simply the reverse side of the prosecution's accusations of dirt and social damage, and how they maintain the distinction of good from pornographic writing by insisting on the literary distinction of the novel on trial. The same structure of thought can be seen to operate in Leavis's approach. The following quotation from his book on Lawrence gives the characteristic tone:

> Any great creative writer who has not had his due is a power for life wasted. But the insight, the wisdom, the revived and re-educated feeling for health, that Lawrence brings are what, as our civilization goes, we desperately need.[26]

In 'revived' and 're-educated', the 're' draws on that sense of a return to something formerly existing but now lost in modern civilization which appeared in Richard Hoggart's statement. The two words combine life – 'revived' – and education. In Lawrence, and perhaps even more in Lawrence's advocates, 'life' is a value whose potency has been covered over or distorted under modern social conditions, and which (great) literature has the vocation of bringing back to us, or bringing us back to. Literature is then by the same token educative, didactic: it will teach us what we have forgotten. The urgency, even emergency, in that emphatic final clause continues the Arnoldian tradition of seeing literature as a desperate remedy (stronger here in its dose than Hoggart's bland 'antidote') for a social situation identified as mechanistic and devalued. Criticism annexes itself here to a function taken to be inherent in the literature whose life-restoring powers it points out.[27]

This linking of literature and life, so forceful in Leavis's appeal on Lawrence's behalf, is reinforced by a strain of Lawrence's own writing, in his novels and elsewhere. It is not only that his novels can be said to offer an image of a different 'civilization'; there is also outright criticism of a negatively represented modernity. In *Lady Chatterley's Lover*, there are several points at which Lawrence's narrator lashes out into decided attacks against the state of contemporary culture:

> The car ploughed uphill through the long squalid straggle of Tevershall, the blackened brick dwellings, the black slate roofs glistening their sharp edges, the mud black with coal-dust, the pavements wet and black. It was as if dismalness had soaked through and through everything. The utter negation of natural beauty, the utter negation of the gladness of life, the utter absence of the instinct for shapely beauty which every bird and beast has, the utter death of the human intuitive faculty was appalling. The stack of soap in the grocers' shops, the rhubarb and lemons in the greengrocers! the awful hats in the milliners! all went by ugly, ugly, ugly, followed by the plaster-and-gilt horror of the cinema with its wet-picture announcements, 'A Woman's Love!'[28]

Here, with 'dismalness . . . soaked through and through every-thing', we are back on Arnold's 'dismal Mapperly Hills' with a vengeance. Instead of a crime and a dead baby, there is 'the utter death of the human intuitive faculty'; and instead of Wragg denied her femininity by the newspaper there is the sequence of crude commodities and the headlined 'wet-picture' title of 'A Woman's Love!', its declarative force sufficient to indicate its unnaturalness when set against 'the instinct for shapely beauty which every bird and beast has'.

The passage works partly by repetition – 'utter . . . utter . . . utter . . . utter', 'ugly . . . ugly . . . ugly', and by loaded words like 'squalid', 'blackened', 'horror', 'awful', 'dismalness', all taken as self-evident evaluative terms and contrasted with their polar-opposite categories: 'the gladness of life', 'the instinct for shapely beauty', 'the human intuitive faculty'. It is fascinating that here, as regularly in Lawrence, the cinema epitomizes what is wrong with modern culture – 'horror', no less (along with the scorn for commerce in general in the form of a random assortment of shops) – but that the view of the town is from inside another thoroughly

modern cultural artefact of the 1920s, the car. The cinema stands for counterfeit feminine emotion and for a cheap veneer (the 'plaster-and-gilt' exterior), yet the car is the place from which the observer with the genuine critical eye can see it for what it is. The reader's view is aligned with that of the speedy narrating traveller who knows with an unquestionable assurance that a film called 'A Woman's Love' is superficial, whereas a novel about the love of a woman called Lady Chatterley is not. And in the same way, Leavis can refer in relation to Lawrence to 'the major orders of value-judgement, those depending on the critic's sense for the difference between what, in his time, makes for health and what makes against it'.[29]

Lady Chatterley's Lover itself partakes of that dismal dismissal of mass culture with which Lawrence's and Leavis's followers became associated. One of the ways in which the unfortunate Chatterley is shown to be thoroughly feeble is by the fact that he is always 'listening in' to the radio. Constance herself calls it 'the emotional idiocy of the radio';[30] it is expressly represented as a poor imitation of earlier sounds of life:

'Will you have Mrs Bolton play something with you?'
'No! I think I'll listen in.'
She heard the curious satisfaction in his voice. She went upstairs to her bedroom. There she heard the loudspeaker begin to bellow, in an idiotically velveteen-genteel sort of voice, something about a series of street-cries, the very cream of genteel affectation imitating old criers.[31]

Lawrence is against all these mechanical things which he opposes to the 'life' values; against the 'velveteen-genteel' veneer, Mellors will set his peculiar version of pastoral, involving a return to a nature of colourful masculinity:

An' I'd get my men to wear different clothes: appen close red trousers, bright red, an' little short white jackets. Why, if men had red, fine legs, that alone would change them in a month. They'd begin to be men again, to be men! An' the women could dress as they liked. Because if once the men walked with legs close bright scarlet, and buttocks nice and showing scarlet under a little white jacket: then the women 'ud begin to be women.[32]

The restoration of a pre-industrial ideal community crucially

depends upon a call for a return to a natural difference of the sexes.

Yet it is revealing that the targets chosen by Lawrence should now seem so inappropriate. The radio and the cinema are two of his favourites; another is the 'gramophone'. The first two at least now themselves have wonderfully authentic-sounding, almost old-fashioned overtones: in the age of television and home videos, there is no great concern with the potentially damaging effects of the radio or film, and certainly not in relation to silent movies or the crackling wireless voices of the 1920s. Where previously they could serve as a symbol of mechanization and commercialization, these two now themselves carry a connotation nearer to that of a lost social harmony.[33] These shifts in the rhetoric should themselves be sufficient indication of the difficulty of maintaining the kinds of clear-cut demarcation that Lawrence (and later Leavis) wanted to assert.

THE TRIAL CONTINUES

In the passage from the novel cited above, the intertwining of sexual and social views of health is once again apparent. As we have seen, the vindication of the novel at its trial rested heavily on the claim that its version of sexual relationships was not only permissible but positively beneficial (with this mode of argument partly determined by the need to prove not only that the book was not harmful, but that it was 'for the public good'). Even though the trial was seen as a watershed for the liberalization of sexual values associated with the 1960s, the case is actually made in quite traditional terms: that Lawrence is promoting a monogamous, heterosexual form of love. Promiscuity is explicitly rejected, homosexual love is not mentioned, and the scene of anal sex – highly euphemistic in the novel itself – is strategically ignored by the defenders of the novel.

I want finally to move to one side and look briefly at a different issue raised in relation to Lawrence's representation of sexuality in the years since the trial. In 1970, the American Kate Millett published *Sexual Politics*, an inaugural work in what has subsequently become the well-established field of feminist literary criticism. Millett proceeded by analyses of texts by male writers as examples or manifestations of the workings of patriarchy. First among these culprits of phallocracy was none other than

D.H. Lawrence. What Millett saw in Lawrence was not dirt exactly, nor wholesomeness either, but maleness of a particularly extreme, misogynistic and offensive kind. Where others would have attributed Lawrence's success to his articulation of commonly held twentieth-century feelings and opinions about human life and values, Millett took it quite simply as a function of his all too clear articulation of the violent, megalomaniac tendencies of masculinity.

Without entering into the details of Millett's criticisms, I would like simply to note two things. The first is that her critique represents one of the first examples of a quite different tendency over the past twenty years in regard to arguments about pornography and obscenity. In 1960, the question is about the lifting of taboos, a new enlightenment in which there is no longer a need to shrink away shamefully from a sexuality that can now be seen as part of the fullness of healthy human life. For Millett, and for a host of feminists since (by no means all feminists, but a significant proportion), the question is about how pornography misrepresents women and their sexuality, does violence to them in a way that may or may not be materially different from actual physical violence, and which may directly encourage it. The pornography–literature relationship has shifted: whereas with the *Lady Chatterley* trial the difference between them was to be maintained very strongly, giving a clear demarcation between good healthy sex and bad vulgar sex – and with literature's figuring as precisely what transcends common, 'street' pornography – now, literature is taken as potentially tainted with the same brush and all the more insidious for being privileged as exempt. Millett's targets have to be 'great literature' in order for her polemic to have some effect. For 'respectable' people already agreed that what is called pornography was unpleasant and violent (though they might not have worried about its being misogynistic). The scandal was to declare that what they thought absolutely different from that run-of-the-press trash was in fact not so at all.

The second point I want to note in relation to Millett's criticism of Lawrence is that in many ways she does not depart from the criteria of her own opponents, just as the defenders of *Lady Chatterley* share common ground with those who attack it. For Millett too has a notion of healthy, wholesome sex between mature people, which – in spite of herself, in a way – is thoroughly Lawrentian. For example:

Though his prose can be as loving a caress to the male body as any of Genet's, it is never as honest. Moreover, the projected masculine alliance, the Blutbruderschaft, is so plainly motivated by the rather sordid political purpose of clubbing together against women, that this too gives it a perverse rather than a healthy and disinterested character, either as sexuality or as friendship.[34]

'Rather sordid', 'healthy and disinterested', 'honest' – the terms are exactly Lawrence's – or Leavis's, for that matter. Once again, there is a firm standard of what is to be thought genuine – honest, disinterested, healthy – and what is not, and this standard is taken as read. It can only be pointed to by the gesture of 'of course' – '*so plainly* motivated', she says – which implies that the writer assumes her reader will agree with her. Millett in this light is a worthy successor to the English tradition of cultural criticism which operates in the declarative mode, assuming clearly separated categories through which the absolutely good (or honest or healthy) is set up unproblematically against its opposite. There is an arbitrary assertion whereby one term is taken as natural and good, the other as a fake or distorted or mechanical substitution for it.

This again is related to the prescribed question to be decided at the trial of *Lady Chatterley*. Before the issue of 'public good' was considered, the jury had first to determine whether or not the work was obscene, with the obscene defined, as noted above, in this way: 'The book is to be deemed to be obscene if its effect . . . if taken as a whole, [is] such as to tend to deprave and corrupt persons who are likely, having regard to all relevant circumstances, to read . . . the matter contained . . . in it.'[35] There is a wonderful contradiction built in here. The jury are supposed to decide, on behalf of the populus at large, whether or not this is an obscene book, whether it has this 'tendency to deprave and corrupt'. (In the case of the Lawrence trial, they were not permitted to take the book home, and sat reading it in a room next to the court for three full days.) If they then *have* been depraved or corrupted, then presumably, by the terms of the trial, they are no longer in a position to judge the book: they have become depraved and corrupt. But they will not know this, because a depraved person is no judge of depravity. There could thus never, in these terms, be such a thing as a fair trial for obscenity. Either it doesn't

corrupt you, which proves it was not obscene in the first place since obscenity corrupts; or it does, but then you are corrupt, no longer a sane, reasonable person, and hence in no position to judge. In either case, you cannot be supposed to know your own state of mind.[36]

This impasse applies in some version to all forms of delegated censorship or cultural 'gatekeeping' (not to be confused with gamekeeping). Someone or some group of people has to take upon themselves the position of superior immunity to whatever is supposed to be potentially harmful in the film or book that is up for consideration. It has the same structure that applies to the insinuation that three shillings and sixpence is a dangerously low price for a high book that might risk looking like a low book (or for a purely, or impurely, low book, quite simply, depending on which side you're on): some people know better than others what's good for 'us'. (There is also the additional contradiction built into the 1959 Act that the saving attribution of 'public good' cancels out the legal but not the alleged psychological effects of an obscene publication, which would still, presumably, be getting on with its depraving and corrupting even while it was compensating for this by its public benefits.)

The same problem, then, that occurs in regard to the distinctions drawn between healthy and unhealthy sexuality, and between genuine and artificial social forms, is built into the very form of the demand that a book be tried for obscenity defined in this way as what tends 'to deprave and corrupt'. The addition of the incompatible escape clause referring to public good only serves to make evident the complicity of the banning of the obscene with the process by which works are legitimated as positively valuable – as tending to revive and re-educate, for instance.

In the case of *Lady Chatterley's Lover* itself, there is a particularly eccentric illustration of this in the forms of an opinion delivered by George Bernard Shaw not long after its first appearance:

> If I had a marriageable daughter, what could I give her to read to prepare her? Dickens? Thackeray? George Eliot? Walter Scott? Trollope? or even any of the clever modern women who take such a fiendish delight in writing able novels that leave you hopeless and miserable? They would teach her a lot about life and society and human nature. But they would leave her

absolutely in the dark as to marriage. Even Fielding and Joyce and George Moore would be no use: instead of telling her nothing they would tell her worse than nothing. But she would learn something from Lady Chatterley. I shouldn't let her engage herself if I could help it until she had read that book. Lawrence had delicacy enough to tell the best, and brutality enough to rub in the worst. *Lady Chatterley* should be on the shelves of every college for budding girls. They should be forced to read it on pain of being refused a marriage licence.[37]

The mixture of the ludicrous and the tyrannical here adds a new piquancy to Leavis's 'force' for life, in this enumeration of the extraordinary controls to be exercised by the well-meaning fatherly dictator lasciviously or sadistically imagining a college full of 'budding girls' for whom the forced reading of a novel prompted by 'brutality enough to rub in the worst' is their only ('on pain of') means of escape into the partially brutal estate of which it has just given them a foretaste. Truly, the wives and servants never had it so good: whether or not the exaggeration is meant as a joke, it is revealing. Shaw presents in an extreme form the argument of many of the novel's later defenders, asserting not merely that *Lady Chatterley* does not corrupt, but that it should be (literally) required reading.

Thirty years after the event to which the title of the transcript refers quite simply as *The Trial of Lady Chatterley*, the issues it raises are again very much to the fore in many areas of cultural representation in Britain. The oppositional language of 'sick' or 'depraved' against 'sane' or 'healthy' individuals or social groups continues to be prominent in relation to issues of pornography, censorship and illegitimate sexualities (the notorious 'Clause 28' ban on the 'promotion' of homosexuality). In many ways, as the vaunted return to 'Victorian' values would suggest, some of the categories and concerns are thoroughly recognizable in the terms of the first legislators against obscene publications and the first advocates of the restorative powers of the literary canon. Attempts continue to establish or police the boundaries between what is thereby decreed to be either dangerous or 'permissible' material. Lady Chatterley may have been vindicated in 1960, but Wragg is still in custody.

Chapter 4

Lolita and the poetry of advertising

Like *Lady Chatterley's Lover, Lolita* was the subject of a major literary-social controversy at the turn of the 1960s involving the relation of unconventional sexuality to an indeterminate borderline between literature and pornography. The public scandal then finds it way right into the book. My British Corgi paperback, for instance, is padded with soundbite testimonials at the back from leading literary experts divided by country and ranging from Lionel Trilling's early defence in *Encounter* ('not about sex, but about love'), to Bernard Levin ('certain of a permanent place on the very highest shelf of the world's didactic literature').[1] There is also the afterword 'On a book entitled *Lolita*' written by Nabokov at the end of 1956, in the wake of initial reactions to the first publication in Paris.[2]

But the scandalous accompaniments are not confined to later additions and editions. *Lolita* also has its spoof Foreword purportedly written by one John Ray, Jr, Ph.D., both defending the book's artistic qualities and placing them in the context of worthy moral deterrence: we can be 'entranced with the book while abhorring its author!' (7). Ray's concluding paragraph decisively categorizes the work as a 'case history' capable of wide and socially beneficial influence: '"Lolita" should make all of us – parents, social workers, educators – apply ourselves with still greater vigilance and vision to the task of bringing up a better generation in a safer world' (7). Nabokov begins his own declaration by referring to the Foreword as 'my impersonation of suave John Ray', and pre-empting its own reading as 'an impersonation of Vladimir Nabokov talking about his own book'.

All this accompanying material, some of it there in the original version of the novel, would make it practically impossible not to

read *Lolita* in the light of a moral question and a potential scandal. The framing texts act as warning signs or obligations to establish a context for *Lolita*, even as they ostensibly exhort the reader to take it on its own aesthetic terms (Ray's conscientious Foreword is recognizably a parody, and Nabokov defends himself against the barrage of moralizing readings which he rejects in the name of literary autonomy). There is thus not even the illusion of an innocent reading of this novel.

The trouble with *Lolita* can be provisionally stated simply in terms of the plot. Where *Lady Chatterley's Lover* involved a question about the defensibility of the heroine's behaviour, here it is the male fictional narrator who is implicitly on trial, not for his murder of Clare Quilty (the crime that has finished him off within the novel), but for his feelings for and treatment of someone who is not just female but too young, and not just young but legally his daughter. According to Lévi-Strauss, incest – the word that Lolita herself baldly utters within the text (126) – is the last, or the first, taboo of human culture.[3] In this sense alone it is a million psychic miles from the stock-in-trade transgressions of a novel of adultery, even with the added barrier of class. Denis de Rougemont, for whom the literature of passionate love always depends for its power on an opposition between social custom and the erotic, saw in incest the one remaining taboo available to the late twentieth-century imagination; Trilling's defence mentions de Rougemont's hypothesis as though in legitimation of this particular theme, and later de Rougemont himself wrote about *Lolita* in these terms.[4]

Throughout its history, *Lolita* has been the subject of arguments veering between the two poles of literary value and pornographic reprehensibility. Ray's defence of the defence – artistic *and* didactic – follows an ancient and honourable tradition, going back to Horace's definition of the functions of literature as a combination of pleasing and teaching, not one rather than the other.[5] But contemporary criticism tends to separate these, taking moral values as not just distinct from but incompatible with those associated with art. More than that, it is in breaking with the moral standards of society that literature's distance from a banal conformity can be measured. Literature's autonomy depends on such a separation, exempting it from moral criteria applicable elsewhere, and removing it from any suggestion of having itself an educative function.

In this context, early praise of *Lolita* would characteristically

make the case by pointing to the difference between art and life. Gabriel Josipovici, for instance, wrote:

> [I]f, from one point of view, Humbert is forced into writing the Memoir by the fear of impending madness and the impossibility of ever possessing Lolita in the flesh, if, that is, the Memoir is simply a poor substitute for the living girl, from another point of view the shift from life to art is the logical outcome of his discovery that he had somehow gone wrong in his previous attempts at capturing the elusive beauty of nymphets. It is not a poor substitute but the true and only way of capturing Lolita and fulfilling his poetic longings.[6]

There is no hint yet here of a defence against the charge that Humbert might have been violating Lolita in 'capturing' her in life or on the page; the case being made, interestingly, is in relation to an implied suggestion that literary fulfilments in relation to women – or nymphets – might be thought to be only substitutes for the real thing 'in the flesh'. We shall come back to this distinction between the real and the fake which is crucial within the novel as well as in its readings.

A later phase of criticism made use of Russian formalism and its development within French structuralism to affirm the separation between life and art as one between worldly morals and textual autonomy. As David Packman puts it:

> According to Donald E. Morton, Humbert 'has used Lolita in his private and subjective way for his own pleasure – and presumably without her knowledge or cooperation'. One could argue that as he composes his memoir, Humbert might share Morton's implicitly dim view of his manipulation of the nymphet. However, quite another, more formal view of the matter is certainly possible. The Russian Formalist notion of motivation permits this other view, from which moral implications are absent. One might say that Lolita has indeed been 'safely solipsized' in that she has become a functional element in the construction of a sequence, a bit of narrative.[7]

The rhetoric of this betrays something bordering on anxiety in the need to find an approach that will let the reader off any moral hooks, literally licensing him ('permits') to forget the problem which none the less remains in the breezy energy of its refusal, and in the need to seek permission for a different approach at all.

More recently, in the wake of feminist criticism, the question of the relations between literature and pornography and their inseparability from a more general cultural misogyny has become less easy to ignore or to relegate to a quick dismissive paragraph. This has been intensified by a sense that structuralist, formalist and then deconstructive approaches have the effect of bracketing off ethical issues by their concentration on a text assumed to be operating in its own world apart from a real one situated somewhere else. But curiously, this then tends to produce a kind of double approach: textual reading plus moral reading, with the separation remaining in place.

Thus Rodney Giblett, having developed an analysis of *Lolita* in terms of its parody of the genre of fictional confession, moves off in a quite different direction by pointing to the way that 'the pleasure it produces for the implied reader is ... compromised by its production of the sexuality of the pubescent girl and the pleasure that that produces for the middle-aged nympholept'.[8] He then stages a kind of replay of the Quilty versus Humbert wrestling match between male doubles by pitting Terry Eagleton and Fredric Jameson against each other as two Marxist critics with opposite notions of the political value of textual sexuality. By the end, Giblett's arena has shifted markedly from his formalist beginnings:

> The construction of this pleasure has both an historical lineage and a politics of gender and generation. By tracing that lineage and enouncing those politics, the material grounds of possibility of pleasure can be critically transformed and the domain of pleasure reinstituted as a site for left-political intervention.[9]

The ethical and political imperative has now taken over completely from the early analysis of the pleasures of parody 'compromised' by their unacceptable content. However worthy the conclusion, the very separation of the two kinds of approach – either an unselfconscious text-for-text's-sake literary *jouissance* at the expense of the girl, or the treatment of texts, and in particular this text, as primarily a place for a politics constituted elsewhere and in advance, not a place for pleasure – has the effect of leaving the problem as it was: either pleasure or political correctness, but not both at once.

In a similar vein, Elizabeth Dipple begins by celebrating the postmodern playfulness of *Lolita*, and then turns to worrying about its theme:

In the late 1980s when the misuse of children is so much before us, the plot of *Lolita* causes uneasiness and many readers stubbornly deny its higher forum of aesthetic excellence. In other words, Nabokov *should* perhaps, at least on one level, have a more exacting moral in tow.[10]

The firmness in the attribution of stubbornness here puts Dipple herself more in the moralist's place than in that of the advocate of 'aesthetic excellence'. In the next sentence, further, the emphatic *should* shows the ways in which the separation of ethics from aesthetics always seems to imply that what is moral is prescriptive in some easily recognizable way, with the noun 'moral' suggesting a general injunction to be followed in the reader's real, as opposed to reading, life.

Dipple goes on, in fact, to argue that the book is indeed a moral work, for all its literary pleasures and ironies, because the narrator does acknowledge that he has wronged the girl: 'This final admission that HH had been guilty of a larger crime than the literary murder of his Quilty–Guilty alter ego necessarily moves the novel into a higher ethical category.'[11] 'Higher' ethics are represented by the replacement of 'his narrow sexual obsession . . . by a genuine love and moral apprehension of the person in front of him'; more than this, even: 'In a very real way, the killing of his guilty Quilty opens Humbert Humbert to a relinquishment of solipsism, and to a selfless poetic act – the immortalizing of a girl who, like him, like Nabokov, like all readers caught in the mesh of time, is subject to death.'[12] What is striking here is the way that every trace of irony, postmodern or not, seems to have disappeared in the thoroughly pre-postmodern appeal to the authenticity of such categories as the whole person, real love (as opposed to base sex) and the pathos of poetic immortality in the face of inevitable human death. This is related to the prevailing use of a language of high and low: the 'higher ethical category', and the 'higher forms of aesthetic excellence' of the first quotation.

Once again, it seems as though it is difficult to talk about ethics in relation to *Lolita* without setting up a division which renders literature, in its supposed divorce from real people and mature attitudes, irresponsible, or childish, or at best salutary (a consolation for mortality). This same impasse – the difficulty of bringing the moral and the aesthetic together – forms the starting point for Linda Kauffman's challenging reinterpretation, like

Dipple's explicitly setting itself in the context of the 1980s focus on issues of child sexual abuse.[13] Kauffman seeks to avoid the stark alternatives which suggest that a text be seen either as simply copying a world awaiting transcription (the representational fallacy), or, on the other hand, as sublimely independent of the social and ethical questions its story may suggest or require. The first, habitually, would be the moralizing version of the kind exemplified by the John Ray Foreword, where the acknowledged enchantments of literature are merely added on as ornament or distraction to texts which in other ways may perfectly well tell it like it is or was – in this instance, the 'lesson-for-our-time' case history. The second version would be the supposed moral insouciance of the often-cited 'aesthetic bliss' invoked by Nabokov's Afterword (332). Unlike Dipple, Kauffman does not see a moral awaiting retrieval from Nabokov's text; but she suggests that it might be 'possible . . . in a double movement to analyze the horror of incest by reinscribing the material body of the child Lolita in the text and simultaneously to undermine the representational fallacy by situating the text dialogically in relation to other texts'.[14]

Reading much more against the novelistic grain than Dipple, Kauffman then finds not the compensatory immortalization of Lolita's body but its violation: 'By thus inscribing the female body in the text . . . one discovers that Lolita is not a photographed image, or a still life, or a freeze frame preserved on film, but a damaged child.'[15] Kauffman reaches this conclusion by way of recent medical literature on father–child incest, which serves more as corroboration than as intertextual counterpoint. It is as though the moral point can only be made, despite every recognition of the difficulties, by returning to a form of referential appeal – 'this is the way it is' – which once again implies that there are some things – some bodies, some acts – which although inscribed, or reinscribed, 'in' a text, none the less carry a meaning independently of it.

It is in one sense ironic that this should be true of incest of all crimes, since – as Lévi-Strauss demonstrated – though the prohibition is apparently a cultural universal, its specific exclusions are infinitely variable. It is worth noticing, too, that Humbert is not Lolita's father in any of the ordinary ways, either biologically or adoptively – he did not bring her up – which emphasizes the arbitrary aspect in all human relationships, including those that do connect blood relations: paternity is here quite literally a legal

form in relation to which bodily desires and acts will come to take their meaning. Far from being a natural or obviously 'material' question of bodily affects, the incest taboo, for Lévi-Strauss, both inaugurates and epitomizes the symbolic order of human culture: 'placing' persons in relation to one another, in terms of permissions and prohibitions which are unconnected with nature.

This is not to say that Lolita is not a damaged child; but to suggest that that phrase gives too much away, from Kauffman's own point of view, to a particular normative cultural fiction, one parodied within the novel, as well as through the Ray preface, which would have it that there is a state of perfect health and wholeness – proper individuality and proper human relations – from which it is possible to make clear-cut demarcations as to just where the damages begin. The extremity of the Lolita case becomes more, not less, forceful as a critique of sexual values if it is acknowledged that it is not without relation to the sanitizing fictions of faultless human growth and relationship.

Apart from the divisions of guilt and innocence, seducer and victim, real love and perverse sexuality, there is another area in which Lolita seems to have suggested to its readers the existence of sharp antinomies; and in this case they are usually taken to be more or less those intended by the author. For the novel apparently stages a manifest clash between the literary values of Humbert and the vulgar, consumerly values of Lolita, which is reinforced through the familiar opposition of the European visitor and the all-American girl. In this antithesis, Lolita does not so much represent innocence and virginity as the crude embodiment of a different kind of victim: one subject to and made over in the image of a mass culture with which she has completely identified; and the narrator, far from representing the force of exploitation, can be associated with an aesthetic authenticity whose plausibility gives the novel its power, because it distracts the reader from what would otherwise appear as a simple assault.

Linda Kauffman implicitly connects these two versions of the antithesis:

> Materialist critiques of the novel could focus on the rampant consumerism of American society in 1955, since Lolita is the ideal consumer, naive, spoiled, totally hooked on the gadgets of modern life, a true believer in the promises of Madison Avenue. Yet a materialist *feminist* perspective enables one to see some-

thing that has not been noted before: Lolita is as much the object consumed by Humbert as she is the product of her culture. And if she is hooked, he is the one who turns her into a hooker.[16]

As the juxtaposition shows, consumer culture and violent seduction are seen to be discursively interchangeable, the first as 'rampant' as a rapist in commonplace critiques, and the victim in the second equivalent to a commodity and then to a prostitute. But as we shall see, the equivalences are not so straightforward: Humbert does not enjoy Lolita in the way in which she might enjoy a soda-pop or a new dress; and if she is 'hooked' on consumer culture, that does not imply vulnerability so much as pleasure.

In a more extended discussion of this aspect, Dana Brand sees the novel as a fairly unequivocal and justifiable critique of consumerism through aestheticism.[17] The normative discourses epitomized by advertising are at once overpowering and alienating for subjects who, by implication, would otherwise be whole: 'Only Humbert the foreigner is able to resist the influence of these new and powerful forms of coercion.'[18] What distinguishes advertising from art is that the former promises, deceptively, to deliver its goods, while the latter is knowingly independent of the real world.

Brand quotes the passage in which Humbert describes the emptiness of night-time Main Street in Appalachia, covered with store signs and brand names, and finds him transforming it into something other than its native commercial character:

A world of shop windows, signs, laxative and lubrication advertisements becomes a beautiful realm of anthropomorphic colored light in Humbert's consciousness. The advertising message in the light is of no importance to him. The name of the liquor store is of less importance to him than the fact that the letters on its sign are 'sherry-red'. The name of the lubrication is important only for what it suggests to him. By aestheticizing the objects he sees, Humbert neutralizes the coercive power they have as signs in commercial American culture.[19]

Yet the power of the brand name of the lubrication oil to suggest something else is not incompatible with its function as an advertisement, but just what is supposed to happen: in advertising terms, the name has made an impression, has led to an association with other words and ideas.[20] 'Sherry-red', moreover, is just the sort of

neologistic compound that an advertising copywriter might invent – or the founder of the European literary tradition, for that matter (Homer's 'wine-dark' sea would seem to be a perfect adjective for the nocturnal liquor store, were it not that Brand has intriguingly metamorphosed what Nabokov gives as a 'Camera Shop' (297)).

Let us try to disentangle these devious and diverse analogies and distinctions among aesthetic, consumerly and moral values as they appear within the novel. We may begin on the relatively secure ground of a literary-erotic tradition, by looking at the way that *Lolita* leads us in one direction to read it in relation to the motif of the *passante* or passing woman, the one and only woman, no sooner identified by the male narrator than she is placed definitively out of reach, to return only in the aesthetic form which restores her to a kind of immortality: 'You see I loved her. It was love at first sight, at last sight, at ever and ever sight' (284).[21]

In the hectic passage across practically every state of America in the late 1940s and early 1950s, in the company or in quest of the irreplaceable object of the narrator's adoration, we are met at every turn by the names of those who represent the European literary and artistic tradition that he has left behind geographically, but that continue to shape the landscape of his desire for the Lolita he never fully possesses as his own: Poe, Baudelaire, Coleridge, Dante, Petrarch, Botticelli, Proust, Rimbaud, Virgil. . . . In one aspect, at least, *Lolita* looks as though it is presenting itself as the continuation, if not the culmination, of a search for the image of feminine perfection in a woman who will necessarily pass on or away, whose very unattainability will be the cause of her continuing power to move the narrator's desire. In this novel, the postulate of the woman's inaccessibility seems to be taken to the furthest possible limit, if not off-limits, in the embodiment of the ideal in the form of a barely pubescent girl. Here, the loved one is fated to disappear not because she may die or because she may leave or never meet him, but because her life span as a 'nymphet' is limited to just a year or two. Unlike Dorian Gray, Lolita cannot become the unchanging incarnation of her moment of youthful perfection. As a girl, moreover, she cannot be had, either legally or in the fantasy of a love that would be shared; and the tragedy of the novel derives partly from the way in which the distance between the two is so clearly maintained even after and in spite of its physical crossing.

At the same time, *Lolita* also departs from some of the standard components of the *passante* romantic scenario. The declaration of unconditional love 'at first sight, at last sight' occurs not at the start, but after Humbert has controlled (and then lost control of) her life for some years, and when she no longer looks like the girl he originally fell for. Possession is followed, not preceded, by a quest (after Lolita goes off with Quilty). And far from being an encounter between strangers walking on a city street, the meeting with Lolita and Humbert takes place in an utterly familial setting: on the lawn of the suburban house where they will soon be living together. This is a novel in which there is almost no walking at all; the car has taken over as the vehicle of undirected cruising. Only the occasional standardized Main Street figures as a distant replica of the city.

And only the young prostitute in Paris to whom Humbert is fleetingly attached before he marries Valeria shows the qualities of the *passante* as *flâneuse*: 'a slim girl passed me at a rapid, high-heeled, tripping step, we glanced back at the same moment, she stopped and I accosted her' (24). It is as though the older setting of the scene has been relegated or confined to the meeting with the actual streetwalker, which does not function in the same way because the dramatic condition of inaccessibility is replaced by its opposite, the assumption of availability. But Monique's appeal is real none the less, and it is in her walk; and the same is partly true of the American girl Lolita:

> Why does the way she walks – a child, mind you, a mere child! – excite me so abominably? Analyse it. A faint suggestion of turned-in toes. A kind of wiggly looseness below the knee prolonged to the end of each footfall. The ghost of a drag. Very infantile, infinitely meretricious.
>
> (45)

In the reverse process to Norbert Hanold's in Jensen's *Gradiva*,[22] the passion for a step here turns into the wish to analyse what produces it; and the 'meretricious' hint at the end operates as a dim echo of the whorish associations of the city to which the suburban girl has no connection.

The encounter with Lolita lacks both mystery and anonymity: there is no wonder in Dolores Haze's presence in her own backyard. And where the scene is without the uncertainties which mark the urban version, it does more than merely domesticate by

the provision of identities on both sides: it also introduces new kinds of dissymmetry by the wide separations of age and culture. And so we have the seemingly unbreachable gaps which will show up throughout the novel: between the older man and the naive girl; between the European and the American; between high culture and consumerism; and, as the version of this last that is most to the fore, between true literature and trash. All these polarities, as they appear in the novel, have in common a distinction – at least at first sight – between the original and the derivative or the fake. They bring together a wide range of themes which might seem to take us too a long way from the vicissitudes of love and literature, just as these two appear to be distant from the questions of contemporary consumerism and national cultures.

Such are in fact the distinctions which the narrator seems to want to maintain, in his constant demarcation of his own pre-occupation with romantic love and aesthetic culture, as opposed to Lolita's indifference to these and her obsession with all the accoutrements of American consumerism. And in this context, it becomes significant that Lolita is not the first love, but very deliberately – in the order of narration, as well as in the order of the narrator's life – situated as second. She is the follow-up – at once replacement and perfect version – for the European Annabel Leigh, introduced on the first page as Lolita's 'precursor'. Rather than Lolita being the one who passes away, it is Annabel who actually dies, her ghost returning in the form of Lolita so that 'I broke her spell by incarnating her in another' (17). The Annabel/Lolita relation, in which it is not clear which is the 'true' love, sets up, from the very beginning, a question about orders of priority between pairs of terms which runs throughout the book.

The America from which Lolita emerges is presented as a place of pseudo-values promoted through how-to books, movies, magazines and consumerism of all kinds, and consistently set against the authentic culture of the European outsider. References to techniques for inculcating norms or establishing norms to be inculcated abound. There is the bizarre experiment of the 'American ethnologist' (33) in California in which Humbert's former wife and her new man participate; there is the research unit to which the narrator is attached as a 'recorder of psychic reactions' (36) soon after he first arrives in the country; there are the numerous asides against psychoanalysis or psychiatry as methods of diagnosis and cure which operate according to inflexible, mechanically

applied standards. Lolita's mother uses a 'Know-Your-Child' book (113), and the educational programme at the school that Lolita attends in Beardsley is directed towards the acquisition of the skills of 'adjustment', with a curriculum summarized like an advertising jingle as 'the four D's: Dramatics, Dance, Debating, and Dating' (186) and deliberately cast as a rejection of European cultural priorities: 'with due respect to Shakespeare, we want our girls to *communicate* freely with the live world around them rather than plunge into musty old books' (187). Humbert's self-appointed mission to raise the level of Lolita's culture is met with a rejection which implies that the process of institutional conditioning against high culture is in any case unnecessary: 'my attempt to refine her pictorial taste was a failure' (210); and in general, 'I could never make her read any other books than the so-called comic book or stories in magazines for American females. Any literature a peg higher smacked to her of school' (183).

Humbert always situates himself as having the overview of high and low, of culture and its debased forms, as opposed to the American females who are identified so completely with the second. So when Lolita's mother, Charlotte, demands details of his former life and lovers, he is able to use this as a strategy:

Never in my life had I confessed so much or received so many confessions. The sincerity and artlessness with which she discussed what she called her 'love-life', from first necking to connubial catch-as-catch-can, were, ethically, in striking contrast with my glib compositions, but technically the two sets were congeneric since both were affected by the same stuff (soap operas, psycho-analysis and cheap novelettes) upon which I drew for my characters and she for her mode of expression.

(85)

Charlotte lives entirely in the world imagined by the sensational genres of her culture; the narrator's art, against her 'sincerity and artlessness', consists both in superior aesthetics and in the duping he mentions 'ethically' as a difference.

This normative culture is manifest at every turn in the travelling across America which occupies much of the space of the novel. In the succession of motels, diners, museums and movies, the narrator suggests that there is nothing to be seen but a perfectly predictable standardization amid the semblance of variety produced by equally homogeneous publicity:

We came to know – *nous connûmes*, to use a Flaubertian intonation – the stone cottages under enormous Chateau-briandesque trees, the brick unit, the adobe unit, the stucco court, on what the Tour book of the Automobile Association describes as 'shaded' or 'spacious' or 'landscaped' grounds. . . . *Nous connûmes* (this is royal fun) the would-be enticements of their repetitious names – all those Sunset Motels, U-beam Cottages, Hillcrest Courts, Pine View Courts, Mountain View Courts, Skyline Courts, Park Plaza Courts, Green Acres, Mac's Courts. There was sometimes a special line in the write-up, such as 'Children welcome, pets allowed' (*You* are welcome, *you* are allowed).

(153–4)

The self-consciously Flaubertian and even more self-consciously 'Chateaubriandesque' references which frame the description reinforce the assumed difference from the literature of the tour-guide, the equivalent American aesthetic being the offer of the landscape as a 'landscaped' place to stay. Seriality – 'their repetitious names' – goes with verbal appeals whose worthlessly 'would-be' status appears to be self-evident.

The account of the trip then comes to resemble a shopping list of things that can be dutifully checked off once each purchase is completed: 'The various items of a scenic drive. Hundreds of scenic drives, thousands of Bear Creeks, Soda Springs, Painted Canyons. Texas, a drought-struck plain. Crystal Chamber in the longest cave in the world' (165). The different stages of the prescribed itinerary are thus all on the same plane, distinguished only insofar as they are amenable to being arbitrarily designated as different from anything else:

The object in view might be anything – a lighthouse in Virginia, a natural cave in Arkansas converted to a café, a collection of guns and violins somewhere in Oklahoma, a replica of the Grotto of Lourdes in Louisiana, shabby photographs of the bonanza mining period in the local museum of a Rocky Mountains resort, anything whatsoever –

(160)

Set alongside each other in this way, all the items can be represented as unique and therefore of value, 'worth the visit'. Roland Barthes describes the operation of this logic in photography which to begin with 'photographs the noteworthy . . . but soon, by

a familiar reversal, it decrees as noteworthy what it photo-graphs'.[23] In the passage above, the Lourdes 'replica' and 'shabby photographs' take this a stage further by suggesting that the copy becomes the object of interest in its own right.[24]

It appears at first sight as though this secondariness of simu-lation might apply only and characteristically to the American scene, which is contrasted, for instance, to the real Lourdes of France, to a Europe which is viewed other than by the standards – the norms and the serial repetitions – of America. But the Europe that seems to figure as a backcloth of authenticity to this artificially 'scenic drive' through the theme park of the new world is also shown as complicit in this construction of America:

> By a paradox of pictorial thought, the average lowland North-American countryside had at first seemed to me something I accepted with a shock of amused recognition because of those painted oilcloths which were imported from America in the old days to be hung above washstands in Central European nurseries.
>
> (160)

The correction to this initial view, American in origin but Euro-pean in its mediated context of reception, is not a true, unbiased view but a sense of 'Claude Lorrain clouds' or 'a stern El Greco horizon . . . somewhere in Kansas' (161), both perspectives equally filtered through European aesthetic stereotypes.

This conversion from American kitsch to European art as a frame in which to see the American landscape acknowledges that the mode of viewing is relative to a culturally informed pre-disposition, but still maintains unchallenged the opposition of value between high and low art, and between the new and the old world. Yet the account of Humbert's early years completely blows apart this distinction by depicting a slice of Europe that is as much a place of images and consumerism as the America he will later discover. His father owns 'a luxurious hotel on the Riviera', and he has a mother described, in a word which both exemplifies and gives priority to the significance of images in relation to their subjects, as 'very photogenic' (11). Her death 'in a freak accident (picnic, lightning)' is placed in the generic context of a sensational news story, a formulaic 'tragedy' rather than a tragedy, along the lines of those Humbert will condescendingly summarize as the stuff of Lolita's trash reading.

What the crossings of American and European images suggest is that the European side cannot maintain its status as a place of origin; or rather, that this value accrues to it only insofar as the perceived secondariness of the new world and its culture of seriality and simulation is necessary to the postulation of Europe's priority and authenticity. These qualities then themselves become effects produced only in relation to this initial assumption of America the reproducible. If this structure is particularly evident in the fantasies of tourism, it can also be seen in the book's fascination throughout, as a theme and in its own use of language and narrative forms, with questions of literature and genre.

Ostensibly, the division is clear-cut between high and low literature, with the narrator setting himself up as the representative of the European literary tradition – both by the constant erudite references, and in his professional work as a writer of scholarly papers and histories of poetry. Clare Quilty, the playwright who is Humbert's rival for Lolita, is opposed to this in every respect: he is American, popular, famous, and contemporary in his productions. At the same time, the distance which separates Humbert from Lolita is measured not just in terms of age but in his conception of her according to the whole European tradition of poetic idealization of the beloved woman, from Virgil and Catullus onwards, against which is set her absorption in the sentiment and melodrama of magazine stories, and her indifference to his attempts to 'raise' her level.

The plot draws loudly on Proust's. Just as Albertine comes after Gilberte, the childhood sweetheart, so Lolita is second to Annabel. And after Lolita's departure, there are direct allusions to the comparable situation in Proust: where one book of *A la recherche du temps perdu* is called *Albertine disparue*, Humbert muses about calling one part of his *Dolorés Disparue* (267); where another is named *La Fugitive*, so is Lolita (217). Alongside this, and as though to mark the distance all the more intransigently, the novel also includes numerous references to the plots of American movies and magazine stories. Unlike the European works mentioned, these are never represented as having a particular author: instead, they are defined in terms of a formulaic resemblance that makes them wholly predictable and, by implication, undistinguished. At one point, on the basis of the 'one hundred and fifty or two hundred programmes' seen in the first year of travelling around,

Humbert proceeds to give summaries of the standard plots of Lolita's three favourite genres:

> musicals, underworlders, westerners. In the first, real singers and dancers had unreal stage careers in an essentially grief-proof sphere of existence wherefrom death and truth were banned and where, at the end, white-haired, dewy-eyed, technically deathless, the initially reluctant father of a show-crazy girl always finished by applauding her apotheosis on fabulous Broadway.
>
> (179)

Similar treatment is then given to 'underworlders' and 'westerners'; in the case of the musicals, it seems obvious that the narrator is tetchily asserting the superior artistic value of 'death and truth' as that which is categorically unacceptable for the 'unreal' wish-fulfilling plot of the film.

Throughout the journeying across the continent, the narrator shows his distance from American culture partly by scattering in-jokes and impossible coincidences which turn out to be a foretaste of the game he will play in the chase with Lolita's abductor, Quilty, who leaves verbal clues all over the place. Key words like 'haze', 'quilt' and 'enchanted' (from the name of the inn where he spends his first night with Lolita) keep appearing; the world seems to shrink to a place where everyone has some direct connection to everyone else, and so they encounter 'an elderly, but still repulsively handsome White Russian, a baron they said . . . who had known in California good old Maximovich and Valeria' (164), Humbert's first wife and her new husband, last encountered back in Paris.

But this puzzle feature indicates too that we should perhaps be wary of adhering too readily to the distinctions between the literary and the vulgar, or the cultured and the consumerly, which the novel seems to be encouraging us to make on Humbert's authority. Literature as no more than quiz-style word-play has none of the poignant or pretentious associations of literature as a great continental tradition of poetic passion.

There are many other ways in which *Lolita* does not sustain its apparent literary distinctions. At the level of specific incidents, there are many moments when the forms and fantasies of film are invoked without the polemical distance which sets them apart from the narrator in other places. For instance, on the night in the

Enchanted Hunters: 'I seemed to have shed my clothes and slipped into pyjamas with the kind of fantastic instantaneousness which is implied when in a cinematographic scene the process of changing is cut' (135). A mode of narration peculiar to film is used not as an example of the lack of realism or truth, but rather the reverse, as the frame in which to understand an experience whose reality is itself shaped by film. Again, 'the davenport scene' (66) earlier on is given a deliberately filmic turn: 'nothing prevented me from repeating a performance that affected her as little as if she were a photographic image rippling upon a screen and I a humble hunchback abusing myself in the dark' (66). On the one hand, the cinematic parallel accentuates both the inaccessibility and the continuing intactness of Lolita; on the other hand, it produces the cinema as the modern medium for picturing the image of the feminine ideal. In a parody of the mechanical element, Humbert then makes the whole episode into a techno-logical recording, repeatable any number of times and suspended indeterminately amid a past, present and future indistiguishable from one another.

The cinematic frame gives Humbert a representation of himself as both spectator and performer, and this is a structure which recurs numerous times in the novel. In this passage, Humbert the resident of the small town of Beardsley projects himself as a series of viewers curious about himself:

I used to review the concluded day by checking my own image as it prowled rather than passed before the mind's red eye. I watched dark-and-handsome, not un-Celtic, probably very high-church, Dr. Humbert see his daughter off to school. I watched him greet with his slow smile and pleasantly arched thick black ad-eyebrows good Mrs. Holigan, who smelled of the plague (and would head, I knew, for master's gin at the first opportunity). With Mr. West, retired executioner or writer of religious tracts – who cared? – I saw neighbour what's his name, I think they are French or Swiss, meditate in his frank-windowed study over a typewriter, rather gaunt-profiled, an almost Hitlerian cowlick on his pale brow.

(198)

And so on for another page, culminating with '[l]etting in a queerly observant schoolmate of Dolly's: "First time I've seen a man wearing a smoking jacket, sir – except in movies, of course"' (199).

For Humbert as much as for Lolita's friend, cultural types are the model for placing someone, identifying them according to familiar parameters. Whether fascistically 'gaunt-profiled' or seductively reproducing the ideal of the 'dark-and-handsome' or the 'ad-eyebrows' blessed with three further adjectives, Humbert's self-surveillance involves looking at himself in the image of the screen character with which he can be safely identified.

Everyone in the novel is seen and evaluated, and sees and evaluates themselves, at two removes or more, according to their acting of parts copied from parts acted in movies or bestselling stories. Charlotte engages in 'a make-believe conversation about a fake book about some popular fraud' (46). A similar accumulation of artifice characterizes Lolita's behaviour; hers looks nothing but a weak derivative of an already weak model as she rushes into his arms with her 'innocent game . . . in imitation of some simulacrum of fake romance' (119). The four levels of this – from romance to fake to simulacrum to imitation – leave the hypothesis of non-faked romance looking like a very dead letter beneath the successive layers of masquerade. But Humbert himself is always part of the same show, knowingly acting up, appealing to Lolita with his movie-star good looks and to her mother with consciously simulated 'old-world politeness' (41), put on in identification with her American fantasy of Europe.

In a similar fashion, the overall plot of *Lolita* is copied as much from the world of the movies as from the more venerable European literary tradition from which it seems at first to take its direction. The farcical side of the double chase in which first Humbert is pursued by Quilty and then Quilty by Humbert is in part, of course, a parody of the 'low' genres of the thriller or detective novel, and the narrator seems to be keeping himself well above them:

> I now warn the reader not to mock me and my mental daze. It is easy for him and me to decipher *now* a past destiny; but a destiny in the making is, believe me, not one of those honest mystery stories where all you have to do is keep an eye on the clues.
>
> (222)

But the various doublings also have the effect of making a mockery of the supposedly original romantic story, and troubling the security of the narrator's ironic distance. The Quilty subplot,

with its exaggerated male rivalry and reversals, functions as the comedy to the tragedy of the main story. As the popular, successful writer, living his flamboyantly debauched life in his *Playboy*-style mansion, Quilty is at once Humbert's double – they are both addicts of sex and literature and they both pursue the other – and the one who serves to undercut the ideals of the pedantic high-culture critic by manifesting them in a satirically low form. The symmetry in the positions of Quilty and Humbert, both in turns the pursuer and the pursued, puts them on a level; by bringing to the fore the rivalry between the two men, it also relegates Lolita to the status of an object of exchange, the contingent occasion for their competition. This trivialization matches the way that the time with Lolita is repeated almost stage for stage with the hompohonic but otherwise completely unresembling Rita (Humbert lives with her for two years and drives all around America with her).

That there is more than a hint of self-parody in these slips of the plot is suggested from the other side by the details Humbert gives of his own literary activities:

> I switched to English literature, where so many frustrated poets end as pipe-smoking teachers in tweeds. . . . I published tortuous essays in obscure journals. I composed pastiches. . . .
>
> A paper of mine entitled 'The Proustian theme in a letter from Keats to Benjamin Bailey' was chuckled over by the six or seven scholars who read it.
>
> (18)

Knowledge of literature is not sacrosanct: it can be played around with for fun and deployed as a professional skill like any other (writing textbooks and college teaching).

For in fact, and in spite of all the narrator's protestations to the contrary, the driving force of the novel's language, what pushes it on from one motel to the next and through all the vicissitudes of the impossible search for Lolita, is not so much its recognizable continuation of a literary tradition as its incorporation into that of the mass-cultural modes that make up Lolita's American world. After her disappearance, there is a moment where Humbert gets rid of 'an accumulation of teen-magazines' (267) from the car:

> You know the sort. Stone age at heart; up to date, or at least Mycenaean, as to hygiene. A handsome, very ripe actress with huge

lashes and a pulpy red underlip, endorsing a shampoo. Ads and fads. . . . Invite Romance by wearing the exciting New Tummy Flattener. Trims tums, nips hips. Tristram in Movielove. Yessir! The Joe-Roe marital enigma is making yaps flap. Glamorize yourself quickly and inexpensively. Comics. Bad girl dark hair fat father cigar; good girl red hair handsome daddums clipped moustache. Or that repulsive strip with the big gaggoon and his wife, a kiddoid gnomide. *Et moi qui t'offrait mon génie.* . . . I recalled the rather charming nonsense verse I used to write her when she was a child: 'nonsense', she used to say mockingly, 'is correct'.

(267–8; italics and second ellipsis in text)

The sentence preciously marked off in French sits pathetically amid the poem in celebration of advertising language which surrounds it; neither the supposed proffering of a nebulous *génie* nor the distance-taking 'You know the sort' at the start can make any appeal against the vitality of the catchphrases and 'nonsense' which works through a racy pleasure in verbal play of all kinds.

Over and over again, the language of consumption, which on the surface is spurned as obviously inferior to the traditions of great literature, seems to take over the poetic force of the novel as though against the grain of the narrator's own intentions. In one sense this is presented as an identification with Lolita's own desires, so that in the afternoon prior to picking her up from the summer camp, the fascination with the girl is shifted by an easy transfer onto 'buying beautiful things for Lo':

Goodness, what crazy purchases were prompted by the poign-ant predilection Humbert had in those days for check weaves, bright cottons, frills, puffed-out short sleeves, soft pleats, snug-fitting bodices and generously full skirts! Oh, Lolita, you are my girl, as Vee was Poe's and Bea Dante's, and what little girl would not like to whirl in a circular skirt and scanties?

(113)

The alliteration of 'p', followed by the fashion-item list of fetishistic details in the style of magazine copy and then the concluding apostrophe, is perfect in its rhythmic precision, which naughtily makes 'Dante's' the cue for 'scanties' so that the esteemed literary lovers are effortlessly elevated or pulled down (by now the two are indistinguishable) onto the dancefloor of American teen culture.

But the poetic speed of consumption also mutates into its opposite, a state of tranquil suspension, underwater slow motion. The noisy jingle metamorphoses into a silently timeless still life, a 'quiet poetical afternoon of fastidious shopping' (114):

> There is a touch of the mythological and the enchanted in those large stores where according to ads a career girl can get a complete desk-to-date wardrobe, and where little sister can dream of the day when her wool jersey will make the boys in the back row of the classroom drool. Lifesize plastic figures of snubbed-nosed children with dun-coloured, greenish, brown-dotted, faunish faces floated around me. I realized I was the only shopper in that rather eerie place where I moved about fish-like, in a glaucous aquarium. I sensed strange thoughts form in the minds of the languid ladies that escorted me from counter to counter, from rock ledge to seaweed, and the belts and the bracelets I chose seemed to fall from siren hands into transparent water.
>
> (114)

There is a distant resurfacing here of Proust's dining-room in the hotel at Balbec, seen by the outsiders peering in through the windows as an aquarium of slow, magical consumption. Here on the inside the 'eerie' atmosphere derives partly from the narrator's being out of place as a man in the women's department, but also from the literal fulfilment of the fantasy that the appeals of consumption constantly promote: that this is just for you, you are the only shopper in the world, and far from you having to do anything to obtain them, the goods will simply float effortlessly into your hands.

Elsewhere the language of consumption is focused more directly on the figure of Lolita herself, an appreciatively responsive reader:

> A great user of roadside facilities, my unfastidious Lo would be charmed by toilet signs – Guys-Gals, John-Jane, Jack-Jill and even Buck's-Doe's; while lost in an artist's dream, I would stare at the honest brightness of the gasoline paraphernalia against the splendid green of oaks, or at a distant hill scrambling out – scarred but still untamed – from the wilderness of agriculture that was trying to swallow it.
>
> (161)

Here the parody of the poet *manqué* is open, as he turns away from modern necessities to find tired clichés of romanticism in the surrounding landscape, while Lo can be 'charmed' by the appurtenances of words which cover the functionally basic, the very lowest of needs, with all the variants of a cutesy kitsch.

The culmination of this ambivalent celebration of Lolita as the poetic consumer occurs at the end of another sequence of the verbal offers to which she so perfectly responds:

> She believed, with a kind of celestial trust, any advertisement or advice that appeared in *Movie Love* or *Screen Land* – Starsail Starves Pimples, or 'You better watch out if you're wearing your shirt-tails outside your jeans, gals, because Jill says you shouldn't'. If a roadside sign said VISIT OUR GIFT SHOP – we *had* to visit it, *had* to buy its Indian curios, dolls, copper jewellery, cactus candy. The words 'novelties and souvenirs' simply entranced her by their trochaic lilt. If some café sign proclaimed Icecold Drinks, she was automatically stirred, although all drinks everywhere were ice-cold. She it was to whom ads were dedicated: the ideal consumer, the subject and object of every foul poster.
>
> (156)

It is Lolita who is the poetic reader, indifferent to things in themselves and entranced by the words that shape them into the image of a desire which consumption then perfectly satisfies. Appearing under the sign of 'novelties and souvenirs', anything can be transmuted through that 'trochaic lilt' into an object of interest, worth attention. It is the narrator who prosaically refuses the fascination with words in themselves or words as moulding the promise of a pleasure for which a referent might then be found, as he stubbornly rejects the promise of the 'Icecold' in favour of a purely informational theory of language which suggests that words and their objects exist in an unvariable twinning of simple denomination.

This fascination with Lolita as the ideal consumer, the American girl *par excellence*, becomes the measure of her inaccessibility to Humbert whose distance in this respect is signalled by his insistence on his own separation from the world that is Lolita's. The language of consumption is represented as being at once the culmination of the poetic tradition and a reprehensible attempt to imitate it. And the infiltration of high and low languages goes in

both directions, so that advertising interferes with the purity of poetry, but at the same time poetry acquires its modern form in the everyday aestheticization of a culture of images.

These tensions are intimately bound up with the framing narrative of the book, somewhere between a legal defence and a psychiatric case history, in which the narrator purports to be accounting for what he did to Lolita. In this text, it is not the woman but the masculine narrator whose sanity is in question, and the early period of his life is reconstructed as a conscious series of pre-Lolitas leading up to the girl herself as perverse fulfilment of the condition that must be satisfied in order for him to desire. Annabel Leigh, the first love who dies, immobilizes his desire in the image of a pubescent beauty doomed to end, and it is she who will come to figure as the poetic ideal impossible to attain in reality. Annabel's desires are perfectly in harmony with the boy's; nothing comes between them except the normal constraints of grown-up intruders and the exceptional curtailment of her untimely disappearance.

Valeria, the temporary wife, is represented, as Charlotte Haze will be later and to some extent Rita too, as of no particular erotic interest, serving only as a decoy or fall-back for the continuing quest to recover and possess an Annabel/Lolita. But between Annabel and Valeria is the Paris streetwalker whose distinctive walk evokes something of 'the nymphic echo' (24). Monique is poised halfway between Annabel and Lolita in other ways than biographically. Like Annabel, she is not significantly different in age from Humbert and there is a degree of shared pleasure, so that 'my last vision that night of long-lashed Monique is touched up with a gaiety that I find seldom associated with any event in my humiliating, sordid, taciturn love life' (25). But at the same time, like Lolita, Monique is a proto-consumer:

> She looked tremendously pleased with the bonus of fifty I gave her as she trotted out into the April night drizzle with Humbert Humbert lumbering in her narrow wake. Stopping before a window display she said with great gusto: '*je vais m'acheter des bas!*' and never may I forget the way her Parisian childish lips exploded on '*bas*', pronouncing it with an appetite that all but changed the 'a' into a brief buoyant bursting as in '*bot*'.
>
> (25)

The frank exchange of money for love here endows Monique with

the power to satisfy her 'appetite' as a consumer of '*des bas*' – combining the femininity of stockings as an article of narcissistic adornment, hugging the skin, with the 'low' emphasis that descends even further in the climactic *bot* of the foot. After this, Monique loses for Humbert what she gains for herself: their next date 'was less successful, she seemed to have grown less juvenile, more of a woman overnight' (25).

It is 'low' consumption which both makes this girl a woman and puts her at a distance from the man by providing another source of satisfaction. In being not (yet) a woman, but absolutely a consumer, Lolita then represents for Humbert another version of this division between the purity of pre-womanhood and the baseness of consumption. She herself is wholly and simply the narcissistic girl-consumer, sexually neither pure nor mature (these are not the categories which make sense from her point of view). Humbert's crime, as he recognizes, is to breach her self-containment by introducing his own, utterly incompatible terms of desire. Before the first night he sleeps with her, Humbert clearly declares that their respective scenarios are not the same:

> Since (as the psychotherapist, as well as the rapist, will tell you) the limits and rules of such girlish games are fluid, or at least too childishly subtle for the senior partner to grasp – I was dreadfully afraid I might go too far and cause her to start back in revulsion and terror.
>
> (119)

The acknowledgement is pragmatic rather than principled: it does not detract from his being 'agonizingly anxious to smuggle her into the hermetic seclusion of The Enchanted Hunters' (119).

In the explicit separation it invokes, this scene replays and extends the one cited earlier when Humbert masturbates on the sofa in her mother's house with an oblivious Lolita: 'What I had madly possessed was not she but my own creation, another, fanciful Lolita; . . . The child knew nothing' (66). The difference between the 'senior partner' and the 'child' is that one is aware of the difference, of the double perspective, and the other has no access to it. There is fantasy on each side – on Humbert's, for his poetic nymphet embodied in the modern American image of the girl; on Lolita's, for the movie-star hero resembling Humbert whose picture she pins to her bedroom wall – but Lolita's has none of the insistence and exclusiveness of his. The problem is not

that such a discrepancy should exist at all (to imagine that it might not, that fantasies are normally or even ideally complementary, would be to accept, on the model of Lolita's high-school training, that human communication is normally faultless). Humbert's crime is to force his version on Lolita in a way that deprives her irrevocably of her 'girlish games' (119) and their ordinary sequels, happy or not.

It is only after this violation that Lolita starts to bargain, as though in acknowledgement that only money can serve provisionally as a regulating standard between the otherwise incommensurable positions in which she and her 'father' are situated. If he can have her, she can have whatever she wants that money can buy. This is the forced contract which is instigated by the array of goods that Humbert buys Lolita on the 'quiet poetical afternoon of fastidious shopping' (114) before he goes to fetch her from the camp; the bribe is followed, the next day, by the compensation, the first of Humbert's numerous lists of commodities:

> I bought her four books of comics, a box of candy, a box of sanitary pads, two cokes, a manicure set, a travel clock with a luminous dial, a ring with a real topaz, a tennis racket, roller skates with white high shoes, field glasses, a portable radio set, chewing gum, a transparent raincoat, sunglasses, some more garments – swooners, shorts, all kinds of summer frocks. At the hotel we had separate rooms, but in the middle of the night she came sobbing into mine, and we made it up very gently. You see, she had absolutely nowhere else to go.
>
> (149)

Here the bare list of things almost unadorned by adjectives or amplifications, just the necessary equipment for the motoring tour to come, is already some way from the dreamy strangeness of the previous afternoon, 'a touch of the mythological and the enchanted in those large stores' (114).

Lolita demonstrates – more enchantingly perhaps than any other novel – that advertising has its poetry, that far from being incompatible, advertising language and literary language share an assumption that objects of all kinds acquire their desirability through the words and the implied stories in which they are represented. There is no separation of form between Humbert's literary world and Lolita's consumerly world; the gap is rather in the incompatibility of the particular wishes and dreams which

make them up. Lolita, 'as glad as an ad' (170), is the modern attraction for the literary seeker after the latest embodiment of youthful female perfection, but by depriving her of her premature 'girlish games' he turns her story into something never shown in the happy world of advertisements.

Chapter 5

A happy event
The births of psychoanalysis

In *The History of the Psychoanalytic Movement* (1914), and again in *An Autobiographical Study* (1925), Freud tells the story of his rupture with Josef Breuer some time after their joint publication of *Studies in Hysteria* (1893–5). The chief cause for this separation, Freud suggests, was their disagreement over the matter of sexuality: Breuer could not accept Freud's growing conviction that there was invariably a sexual component in the aetiology of hysteria. This was true of almost everyone, Freud implies; but in Breuer's case there was a particular and paradoxical reason for his disbelief: he had discovered it himself at first hand, and did not want to know what he none the less knew only too well.

It was something to do with the ending of Breuer's celebrated case of Anna O., the first patient to be successfully treated by the 'cathartic' method of what she called the 'talking cure', and the first one to appear in Breuer's and Freud's joint study of hysteria. Of this patient, Breuer had written with apparent confidence on the very first page of his account that 'the element of sexuality was extraordinarily undeveloped in her' ('Das sexuale Element war erstaunlich unentwickelt'). The Anna O. case was thus both the least amenable to the sexual-causation hypothesis and the most important for its credibility; and it is with all the skills of a writer of thrillers that Freud builds up the suspense, speaking of Breuer's unwillingness at first to publish his findings about the uses of hypnosis in the treatment of hysteria, and letting the readers of the *Autobiographical Study* know in advance that a mystery lurks:

> The patient had recovered and had remained well and, in fact, had become capable of doing serious work. But over the final stage of the hypnotic treatment there rested a veil of obscurity

[ein Dunkel], which Breuer never raised [aufhellte] for me; and I could not understand why he had so long kept secret [geheim] what seemed to me an invaluable discovery instead of making science the richer by it.[1]

Freud then keeps his own readers in the dark for several more pages, before providing the following elucidation:

> After the work of catharsis had seemed to be completed, the girl had suddenly developed a condition of 'transference love'; he had not connected this with her illness, and had therefore retired in dismay. It was obviously painful to him to be reminded of this apparent contretemps.[2]

'Apparent contretemps' ('anscheinender Missgeschick') is a striking phrase, enigmatic even in the supposed relation of an enigma. And indeed it is not unique, but harks back to two others Freud had used in writing about the same affair twelve years before. In the History, he mentions Breuer's 'unwelcome discovery' ('unerwünschten Entdeckung');[3] he had given a more expanded account several pages before:

> Now I have strong reasons for suspecting that after all her symptoms had been relieved, Breuer must have discovered from further indications the sexual motivation of this transference, but that the universal nature of this unexpected phenomenon escaped him, with the result that, as though confronted by an 'untoward event', he broke off all further investigation. He never said this to me in so many words [keine direkte Mitteilung gemacht], but he told me enough at different times to justify this reconstruction of what happened.[4]

But it would seem that Freud cannot say it directly, 'in so many words', any more than can Breuer. This 'untoward event' is in English in the German text, with italics and quotation marks together reinforcing the paradox of an 'unexpected phenomenon' ('unerwarteten Phänomens') that is none the less of a 'universal nature'. But even in English, the 'untoward event' is no ordinary expression. The adjective 'untoward' is nowadays used only in this combination, which has the slightly self-conscious air of a closed expression proclaiming that it is pregnant with some hidden meaning which it is nevertheless not going to reveal. Further, though 'untoward' might suggest an unthreatening

alternation with the reassuringly positive form from which it seems to be derived, this is not the case: the corresponding 'toward' event does not exist.

'Apparent *contretemps*', 'unwelcome discovery', 'untoward event': three suggestively synonymous phrases ('untoward event' is in fact given in the Oxford English Dictionary as one of the expressions equivalent to the anglicized 'contretemps'). As well as a shared mystery, there is a surprising confusion of languages in all this murmuring. James Strachey takes a French-sounding word to translate into English the German *Missgeschick*, and Freud himself on another occasion produces the English 'untoward event'. The *contretemps*, it would seem, is no respecter of linguistic boundaries; phantom-like, it is prone to appear, or apparently to appear, in a foreign guise, reluctant to naturalize itself or to give away – to expose and to lose – its identity. Perhaps the *contretemps* can only be apparently a *contretemps*, darkly hinting in a strange tongue at a secret it may or may not really harbour.

And Freud, after all, has not gone very far in enlightening his readers about the ambiguity surrounding the end of Anna O.'s treatment. There is a disproportion between the extravagant expectations provoked by the 'veil of obscurity' and the crisply professional diagnosis of 'transference love', which is all that is said in either text. Has he really revealed all there is to say about this crucial *contretemps*? And as if recognizing that Freud's ending, like Breuer's, is too abrupt, Strachey adds a tantalizing footnote at this point in his translation: 'The full story', he says, 'is told by Ernest Jones.'

For the moment, though, we must hold back further investigations along this line: the time has not yet come. For this mixture of languages is reminiscent of something: of Anna O.'s 'talking cure', in which the strange events she had to recount necessitated a passage through languages other than her native German. At one point, for instance, quite early on in the treatment:

> She now spoke only English and could not understand what was said to her in German. Those about her were obliged to talk to her in English. . . . She was, however, able to read French and Italian. If she had to read one of these aloud, what she produced, with extraordinary fluency, was an admirable extempore English translation.[5]

But the three strange phrases suggest another association as

well. Elsewhere in the *History,* Freud describes a peculiar memory, or rather a sequence of memories, which had emerged after he had become convinced of the significance of sexuality for hysteria (in the *Autobiographical Study,* he says it was writing the *History* which brought them out). There came back to him three chance remarks which had been made to him at various points in the fairly distant past by eminent physicians – Breuer, Jean-Martin Charcot and Rudolf Chrobak. Breuer had alluded with such archaic obscurity to secrets 'of the alcove', *'des Alkovens',* that he had taken Freud's incredulity at the sexual suggestion for a simple gap in vocabulary, helpfully glossing the word as *'des Ehebettes',* 'marriage bed'. Charcot had animatedly declared: 'C'est toujours la chose génitale . . . toujours . . . toujours'; and Chrobak's contribution had been the facetious prescription in Latin duly displayed on the page in three lines: 'R. Penis normalis/dosim/ repetatur'.[6] All these comments seemed now to be pointing to the same 'thing' as Freud's own hypothesis – confirming it, but by the same token depriving it of originality:

> These three identical opinions [*identischen Mitteilungen*], which I had heard without understanding, had lain dormant [*geschlummert*] in my mind [*in mir*] for years, until one day they awoke in the form of an apparently original discovery.[7]

Strachey's 'in my mind' for *'in mir',* 'in me', cerebralizes what seems in other respects to be a perfectly normal, if rather lengthy, process of gestation. As though repeating the peculiarities of hysteria itself, Freud represents the genesis of his conviction as to the sexual nature of the disease as a perverse pregnancy, and as an extraordinary synthesis of three statements made in foreign or ancient words.

The remarks which had been lying dormant within him re-emerge after many years, forgotten but insistent memories whose time has now finally come. They come out verbatim, almost too directly, each thrusting its way obtrusively into the German text. But once they are out, it seems, as with Anna's daily 'chimney-sweeping' of her thoughts in what she told Breuer in the evenings, they can be forgotten once and for all as no more than common-place pieces of smut. For they are now all three assimilated into equivalent, even identical, pieces of evidence, transformed into a collective confirmation of one of the principal postulates from which psychoanalysis will be developed. The distinctness of the

three fathers is effaced in their engendering of 'identical' children. But the transition cannot be as smooth as all that. For the true *contretemps*, surely, must not be Breuer's personal embarrassment but the invention of psychoanalysis itself, that untoward event *par excellence*. *Contretemps, contre-temps*. For after the uncomfortable birth of psychoanalysis, time was no longer what it had been, 'before' and 'after' entering into new and hitherto unimagined relations of complicity and interference. The unconscious is indifferent to the measure of the ordinary time with which it never ceases to meddle, impinging with some forgotten or unthinkable past event upon a now for which it is always inadmissibly offbeat, untimely, untoward. Embryonically present in Breuer's account of Anna O.'s *absences* and her *condition seconde*, and in the insistent return of the reminiscences from which she suffered, psychoanalysis is the *contretemps* itself, time and counter-time at once.

But it was the insistence upon the wide significance of sexuality which was to determine the violence of the reactions to psycho-analysis, which Freud describes in these texts. Breuer, once again, is singled out in this context as being 'the first to show the reaction of distaste and repudiation [*der unwilligen Ablehnung*] which was later to become so familiar to me, but which at that time I had not yet learnt to recognize as my inevitable fate [*unabwendares Schicksal*]'.[8] Freud's posture here of heroic isolation transforms the one who could have been his co-founder into his first enemy. The *contretemps* of the ending of the Anna O. case provoked a separa-tion because of the realization that there had been love; the same *contretemps*, in the form of the acknowledgement of sexuality as part of hysteria, is reinterpreted to provoke a new one, the separation of Freud and Breuer and the end of a close relationship.

But the time has now come at last to turn to the pages of Ernest Jones's biography which Strachey promised us would reveal the full story. And sure enough, when we reach the relevant passage, we find immediately that alongside or before the reason for Breuer's 'retirement' mentioned by Freud is a second, comple-mentary tale:

It would seem that Breuer had developed what we should nowadays call a strong counter-transference to his interesting patient. At all events he was so engrossed that his wife became bored at listening to no other topic, and before long jealous. She

did not display this openly, but became unhappy and morose. It was long before Breuer, with his thoughts elsewhere, divined the meaning of her state of mind. It provoked a violent reaction in him, perhaps compounded of love and guilt, and he decided to bring the treatment to an end. He announced this to Anna O., who was by now much better, and bade her goodbye. But that evening he was fetched back, to find her in a greatly excited state, apparently as ill as ever. The patient, who according to him had appeared to be an asexual being and had never made any allusion to such a forbidden topic throughout the treatment, was now in the throes of an hysterical childbirth (pseudocyesis), the logical termination of a phantom pregnancy that had been invisibly developing in response to Breuer's ministrations. Though profoundly shocked, he managed to calm her down by hypnotizing her, and then fled the house in a cold sweat.[9]

'The full story', if this is the full story, was certainly worth waiting for. Anna O., Breuer tells us, loved dancing and the source of her nervous cough could be traced to her guilty enjoyment of dance music coming from a nearby house when she was sitting beside her sick father. Rhythm, *contretemps*: it takes two to tango, and Jones immediately doubles or more than doubles Freud's revelation of (Anna's) transference love when he puts the question of Breuer's involvement, or fear of his possible involvement, first.

All this is disturbing enough; and the 'phantom' pregnancy and delivery seem to be an especially grotesque illustration of the depth and nature of the patient's attachment. But this is not yet the whole story: there is one further detail to come, which we have so far held back. Jones's next sentence, following the 'cold sweat', has a terrifyingly normal air:

The next day he and his wife left for Venice to spend a second honeymoon, which resulted in the conception of a daughter.[10]

From the interchange of ever more unmentionable loves and influences, 'these curious circumstances' as Jones will put it, a real child is born – in perfect bourgeois legitimacy. Even more than the other woman's phantom pregnancy, this new baby makes its appearance as a harbinger of what will be the psychoanalytic discovery of the complex erotic story that lurks beneath the most conventional sexual or apparently asexual surface. What looks like the ideal 'happy event' of matrimonial dreams or duties is in

fact nothing else but its own travesty, the product of illegitimate desires. Freud's sexual findings will invert the usual protocols of description, condemning the normal to being no more than a particular, if common, case of a ubiquitous perversity. Behind the veil of domestic predictability (where else than Venice, after all, for that romantic renewal?), the birth of this new baby to a married couple conceals the *contretemps* which induced it. And just as Freud is convinced that an 'unexpected phenomenon' may turn out to be universal in nature, insists that the sexual aetiology of a single case may reveal what is true of all cases, so the new Breuer child suggests that every happy event is at the same time an untoward event. (And Freud will go on to suggest that every first honeymoon is always in a sense a second honeymoon, the first consummation having been imagined with others long ago.) The apparently normal casts its 'veil of obscurity' over what is actually always a *contretemps*.

But this accident of birth has a further peculiarity. Just as the mention of the transference follows that of Breuer's own counter-transference, so the account of Anna O.'s hysterical pregnancy is preceded by the statement that Breuer too was 'engrossed'. Like Anna O.'s, Breuer's phantom pregnancy miscarries, adding to the mess that is concealed behind the euphemistically suggestive 'untoward event'. These things cannot be named – there are no names for these things. But Freud himself can apparently carry his own male pregnancy to term. Where Breuer's labour mis-carried, Freud proudly presents his sleeping triplets for all the world to see.

Yet the story does not end here. The feminine identification implicit in Freud's description of the foetal remarks was ostensibly a means of giving credit to other men for the 'apparently original discovery'; in place of a pure parthogenesis, Freud finds he has been promiscuously inseminated by no less than three putative fathers, the authors of the three enigmatic remarks. This attri-bution is quickly qualified, however, in the very moment that it is reaffirmed following the detail of the three unknowingly knowl-edgeable utterances:

> I have not of course disclosed the illustrious parentage of this scandalous [*verruchten*] idea in order to saddle other people with the responsibility for it. I am well aware that it is one thing to give utterance to an idea once or twice in the form of a

passing *aperçu* [*flüchtigen Aperçus*], and quite another to mean it seriously – to take it literally and pursue it in the face of every contradictory detail, and to win it a place among accepted truths. It is the difference between a casual flirtation [*einem leichten Flirt*] and a legal marriage, with all its duties and difficulties [*einer rechtschaffenen Ehe mit all ihren Pflichten und Schwierigkeiten*]. '*Epouser les idées de . . .*' is no uncommon figure of speech, at least among the French.[11]

Let us try not to be too shocked by this scandalously abrupt reversal of the psychoanalytic scandal. It appears to turn the clock backwards, or rather to let it run normally again, reinstating the old standards of decent behaviour which the emergence of psychoanalysis had upset with its distressing *contretemps*. What are we to make of it when Freud, who had just been announcing the birth of psychoanalysis in rather curious circumstances, calmly alludes to the superior value of proper, marital relationships, arduous though they may be, as if it were the most natural thing in the world (and especially among the French, apparently)? As if there were no more to be said, and any crackpot who took it upon himself to challenge the obviousness of heterosexual monogamy should be treated with the contempt that he deserved. Unless this is just some remark made in passing, for which it would be unfair to hold him responsible, Freud seems to have secured a rapid switch of identity. He is no longer the mother of psychoanalytical insight into sexual causes, outrageously pregnant by three men at once, but instead its legal father and proprietor, the *paterfamilias* resolutely going about the defence of his offspring in order to 'win it a place among accepted truths'. And here Freud and Breuer are momentarily reunited, for both, in the end, react to the same unwelcome discovery about the scope and shape of human sexuality by the compensatory fathering of a legitimate child.

And now, one of the three enigmatic phrases that we noticed a little while ago seems to return with a somewhat altered aspect. In looking at the series of expressions that mentioned but did not enter into the detail of Breuer's difficult discovery, we focused on what looked like the similarity between the 'unwelcome discovery', the 'untoward event' and the 'apparent *contretemps*'. But these are not, in fact, identical expressions and it might be a mistake to see them all as leading to the same conclusions. What, after all, is an *apparent contretemps*? A *contretemps* which appears to

be so but is not, or might not be, could well be precisely the opposite: a fortunate accident, or a happy event.

And if we pursue the passage more closely with this in mind, and in the face of contradictory detail, it seems that this is precisely what Freud is implying. It was only an apparent *contretemps*, because though it had stopped Breuer in his tracks it was the very thing that would enable Freud himself to forge ahead.[12] The one case which had apparently been blocking the way to certainty about the universality of the sexual factor in hysteria now turned out to represent a magnificent confirmation of the thesis. Breuer's *contretemps* becomes Freud's royal road to the invention of psychoanalysis as the science of the *contretemps*.

A happy event, apparently.

Indirectly, this chapter arose from an interest in the debates surrounding what have become known as the new reproductive technologies, which are the subject of the next chapter. Around the question of reproductive 'choice' (at an earlier stage, this was orientated more to the issue of abortion than to the enabling of reproduction), there has been very little drawing on psychoanalytic ideas about the wish to have (or the wish not to have) a child being bound up with the prospective parent's fantasies of himself or herself as mother or father, and man or woman. Instead, the argument has tended to be polarized into a straightforward opposition: either the new technologies enhance a woman's (and sometimes also a man's) rational 'right to choose', or they demonstrate further encroachments by technology, identified as masculine, on what would otherwise be women's natural capacities to mother.

Some of the recent changes have far-reaching, even fantastical potential for modifying what have seemed to be immutable differences and dissymmetries between the sexes in their relation to the function of parenthood. Surrogate motherhood (when a woman who is not to be the one who raises the child carries it in her womb, conceived either from her own ovum or from that of the future mother) splits into two or three elements what had appeared to be the unified and indisputable condition of mother. Now there is the social mother (who brings up the child) and the biological mother(s), the one who provides the egg and the one who carries the foetus in her womb. Fatherhood, on the other hand, loses its mystery when *in vitro* or other forms of aided

fertilization or insemination are used: the sperm is transferred from an identifiable source. And so the age-old discrepancy between the known mother and the putative father (*pater semper incertus est*, a function which must be arbitrarily added on; Joyce's 'Paternity is a legal fiction') seems to be breaking down, or at least altering.

Keeping to a simple opposition between science and nature, these developments appear either to further human choices (both men and women, indifferently, may opt to be parents) or to thwart human nature (where women and men are different). But they could also be regarded as shedding some backward light on potentials and uncertainties about the differences and similarities between the sexes which were perhaps there all along, even if they may show up in sharper focus now. It is here, perhaps, that psychoanalysis's understanding of the desire for a child, or the desire to take up the place of mother or father, in terms of fantasies which cannot be seen as only a matter of reasonable decision, or nature, or imposition, may have something else to contribute – though, as always when psychoanalysis is brought to bear on a social or political issue, there will not be one simple answer.

Frankenstein's woman-to-be
Choice and the new reproductive technologies

In Mary Shelley's *Frankenstein* (1818), there is a moment when the scientist, engaged in making a female version of the monster he has already created, for the first time speculates on the possible consequences of this, wondering whether she may not turn out to be something other than the perfect companion and mate that he intends. His misgivings extend to several paragraphs, and are worth elaborating in some detail:

> Three years before, I was engaged in the same manner and had created a fiend whose unparalleled barbarity had desolated my heart and filled it forever with the bitterest remorse. I was now about to form another being of whose dispositions I was alike ignorant; she might become ten thousand times more malignant than her mate and delight, for its own sake, in murder and wretchedness. He had sworn to quit the neighbourhood of man and hide himself in deserts, but she had not; and she, who in all probability was to become a thinking and reasoning animal, might refuse to comply with a compact made before her creation.[1]

The opposition presented in these first points between barbaric and civilized dispositions or behaviour is itself based on a deeper assumption that an individual is capable of deciding, in its 'thinking and reasoning' way, what s/he wants, and whether or not to conform to the rules laid down before it and for it. On the grounds of bitter personal experience, Frankenstein knows that no parent – not even the single parent with absolute control, as he was – can condition or programme in advance the nature of an offspring. No difference in this respect follows because the new creature will be female; instead, like her mate, she is treated as a

contract-making being. However bad she might be by inclination or resentment, she, like him, would be capable of entering into a binding agreement, and that is why it would be impossible for such an agreement to have been made without her separate consent.

Frankenstein then goes on to consider another area of potential difficulty, this time concerned not so much with the creature as an individual *per se* as with the fact that the single individual will now have become a group of two. He wonders what would happen if the pair turned out to hate each other, so that the original monster was once more left without a mate. For just as he might not take to her, so 'She also might turn with disgust from him to the superior beauty of man; she might quit him' (435). Here, the new woman is taken to be a creature of strong physical attractions and revulsions, reacting with desire or 'disgust' to the bodies she encounters. Her feelings are not rational or calculating, but derive from aesthetic comparison, with a 'superior beauty': her disgust is related to a counter-attraction to something she prefers.

Both these considerations assess the dangers in relation to the dispositions of an individual acting according to her personal inclinations, rational and emotional. But there is yet a third problem which the creation of a female might bring with it:

> Even if they were to leave Europe and inhabit the deserts of the new world, yet one of the first results of those sympathies for which the daemon thirsted would be children, and a race of evils would be propagated upon the earth who might make the very existence of the species of man a condition precarious and full of terror.
>
> (435–6)

Here the danger of a woman is not that she is 'a thinking and reasoning animal', or that she has particular likes and dislikes in relation to others' bodies, but that she is a breeder. Where the first problem took her for a reasoning mind, endowed with the right and the capacity to consent or not to particular kinds of behaviour, and the second accorded her physical desires, this last fear looks upon her as a female body which does what it does – produce offspring – irrespective of personal choices, of whatever kind, the children resulting only from 'those sympathies for which the daemon thirsted'.

In a very concise form, Frankenstein's three anxieties bring into focus two kinds of uncertainty, both of them recurring modern questions: about the necessary unpredictability of the dispositions of a future subject, even one produced out of the most planned of parenthoods; and about the nature of women, in their resemblances to and differences from men. Insofar as the second question, about what a woman is and what she wants, always comes to involve her capacity to bear (and her tendency to rear) children, and the ways in which this in turn may impinge upon other capacities and potential desires, it is intimately bound up with the first.

The notion of women's natural wish for children – the 'maternal instinct' – itself developed during the period, not long before *Frankenstein*, in which the question was also beginning to be raised as to whether women, like men, were 'thinking and reasoning' beings;[2] the *Vindication of the Rights of Woman* (1792), written by Shelley's mother, holds the two together by presupposing the naturalness of both reasonable and maternal characteristics. For Mary Wollstonecraft, what distinguishes women from men is not the possession of reason or emotion (both have both, and women have been too much denied the development of the former), but the additional possession of a womanly wish and capacity to mother.

But changes in the conditions of mothering over the past hundred years have made it increasingly difficult for women's reproductive dispositions to be taken for granted. In the twentieth century, for the first time in history, the widening availability of contraception and then abortion have made it possible for most women in western societies to have some control over whether and when they have children. The slogan 'A woman's right to choose' well illustrates the way in which childbearing can now be represented on the model of the freedom of the 'thinking and reasonable animal'.[3]

At the same time, the new reproductive technologies, while shifting the emphasis from the right *not* to have to the positive right to have children, have been represented within a similar rhetoric of individual rights and access. More and more, becoming a mother then takes the form of an active choice or wish, whether in seeking or preventing a pregnancy; but it is not at all clear how such a choice is to be understood, to what extent it does or does not resemble choices of other kinds. The very effectiveness of 'a

woman's right to choose' or 'the right to control one's own body' as punchline slogans necessarily obscures questions about how far discourses of rights and choice, by no means identical in the first place, might or might not be appropriate to the area of reproduction.

Recent advances (though that word already begs too many questions) in reproductive technology raise questions of staggering complexity about the possible future forms of subjecthood and, by extension, about the desirability and implications of technical innovation and intervention in the making of human lives. How, for either sex, is the wish to bear or make a child to be understood? And what kind of identity is the child that arrives expected to need or to find in the social world into which it is born?

The principal new possibilities of the past ten or fifteen years have centred on forms of *in vitro* fertilization, egg and sperm donation and surrogate mothering. Their effect has been to break down into component parts the various biological functions of conception, pregnancy and birth which previously made unproblematic the assumption that a newborn child had two identifiable parents, one of each sex. In effect, biological mothering has been divided into two functions that are no longer, as before, necessarily combined in the same female body: that of the woman who provides the egg, and that of the woman who carries the child to term. (It is significant that the word 'surrogate' implies a secondariness which is not assumed for instance in the French expression, *mère porteuse*, or 'carrying mother'.) In most cases of surrogate motherhood, the egg is also that of the pregnant woman, though sometimes an egg from the future social (or 'rearing') mother is fertilized *in vitro* and then implanted in the womb of the surrogate mother. The term 'surrogate mother' is not, however, applied to the cases where the future rearing mother is implanted with an embryo whose egg is that of another woman (this is a practice increasingly adopted with older women whose eggs have 'aged').

The potential disjunction between biological and social parenting has been in existence since time immemorial, through formal and informal practices of adoption: Freud was fascinated by the 'family romance' in which a child imagines himself or herself to be adopted, and really the child of parents of higher social status than his own. But the new division within the biological aspect of mothering has the effect of breaking down the age-old

dissymmetry, according to which a mother was always identifiable as the woman from whose body the child emerged, whereas a father could never be known for sure: *pater semper incertus est*. (Now, indeed, biological paternity comes much closer to certainty when it involves the transfer of sperm for artificial insemination or *in vitro* conception, and the possibility of genetic verification.) Another set of changes involves the technology of pregnancy, and here a slightly different set of questions arises. Increasingly sophisticated scanning devices are able to detect defects in the foetus, which then entails a decision as to whether or not to abort. In this connection, the foetus is treated as less than, or not yet, human: it does not have the rights to life of a subject. But at the same time, the way that foetal outlines and movements can now be watched on video screens has the effect of bringing forward the moment of imaginary humanity; anti-abortion campaigners in the United States made use of this in a film promoting their cause.[4] This aspect has been reinforced by the continuing reduction in the age of 'viability', when a foetus can potentially survive outside the womb.

The new technologies raise questions of unimaginable difficulty about the significance – for either sex, but especially for women – of the wish to have, or the wish not to have, a child, and about the possible implications of their use and development for the futures of human subjectivity. In relation to these changes, mothers, fathers and children no longer fit into the same recognizable symbolic places as they seemed to before, which means – for better or for worse – that the structure of the classic oedipal triangle – father, mother, child – might come to look very different. But the issues have barely been broached other than in the languages of either individual rights or natural desires, which seem to fall short of the complexity that has to be addressed. As the psychoanalyst Monette Vaquin puts it:

> We are completely ignorant as to the effects on the psyche of the division of maternity, or exchanges of gametes. And while it is true that filiation in humans is not reducible to biology alone, it is no less true that one cannot manipulate gametes without inevitably manipulating psychical investments of which we are not in control.[5]

Broadly, two positions confront one another in the debates in this area. One line of argument holds that the new technologies simply

represent one more turn of a thoroughly masculine scientistic scalpel. As in the case of Frankenstein, male ambition – a quasi-naturalized element – produces a need to conquer the one territory that seems by nature not available for artificial control or supersession: that of human reproduction. In the attempt to make the production of babies a matter of hospitals and laboratories, women are reduced to the status of machines or animals, serving the needs of masculine hubris and deprived of their natural ways of being mothers.[6] In this representation, as with Frankenstein's third possibility, women are indeed breeders, but this is not in itself the problem. Technology is an interference with a natural endowment, which is something to celebrate and a source of envy in the other sex.

The reverse position also sees women (though not necessarily all women) as wanting to bear children, but far from identifying a male scientific conspiracy against them, regards the new technologies as a straightforward adjunct, assisting them in bringing this about. Here, both women and men are reasonable creatures who know what they want and are justified in seeking to find the means of obtaining it (or, in cases where no child is wanted, preventing it). If science is increasing the chances for those who would otherwise not have been able to have children to do so, then this should be seen as something positive. No one would dream of objecting to the discovery of a cure for cancer on the grounds that it had been brought about through men's wish to make a name for themselves; in the same way, in this view, the new technologies unproblematically stand for the progressive removal of impediments for those who want to have children. The model involves reasonable individuals on both sides – patients and doctors, or scientists and prospective parents – working together to remedy a mutually agreed deficiency. People's desire to have children is taken as fundamental and compelling, as worthy of treatment and research to make its fulfilment possible; but it is not in itself an object of enquiry: if you want children, there is no reason why medicine should not assist you in having them.

In these ways of representing the problem, the distinctions are straightforward: agency versus victimization, or choice versus imposition. Either women's right to choose is continually being enhanced by scientific progress, or else a masculine medical culture is eroding what would otherwise be women's natural

ways of choosing to be mothers.[7] But the current mutations in the conditions of reproduction call for more subtle analytical tools – capable of discriminating between different technologies and of thinking about the ways in which human subjects identify themselves, whether as mothers, fathers, men, women or children (or, for that matter, as scientists).

In the Freudian texts discussed in chapter 5, the meanings of desires for pregnancy, paternity and scientific achievement move between the sexes in ways which suggest that none of them is natural. Freud saw nothing automatically given in a woman's desire to have a child or a man's desire to be a scientific hero, however commonplace either case might be.[8] In particular, and notoriously, he came to see women's desire for a child as representing the lingering substitute wish for the penis of which she had been deprived. Whatever the validity of this interpretation, now or then, Freud's account is crucial in its refusal of any notion of reproductive choices or scientific research as simple matters requiring no further explanation. Just as the process of identifying oneself as a man or a woman is in no way straightforward, a natural development according to the sex of the subject's body, so identifications as prospective mother or father, whether in relation to actual childbearing or, by extension, to scientific and other productions (Freud's pregnancy and paternal lineage, as we have seen in chapter 5), are understood as part of the stories that people tell themselves about who they are, have been and might or will be in the future.

But these stories, in all their likely versions, and for children as well as for mothers and fathers, are themselves potentially subject to modification from the possible changes in the forms of familial identification that the new technologies seem to promise or threaten. Both the types of development described above – those to do with surrogacy and *in vitro* fertilization, and those to do with the foetus – involve legal and ethical issues about the rights of foetuses, babies and parents, and the definitions of each of these categories, in a field where the conditions are constantly shifting and where there are no established terms of judgement.[9]

If a surrogate mother decides she wants to keep the child after all, there is no clear model on which to adjudicate the dispute between her and the prospective parents. Her claim on the basis of biology – either the fact of having carried the child during pregnancy, or, additionally, the fact of providing the egg – is

countered by the prospective parents' claims on quite other grounds, those of an established contract. As with Frankenstein's speculations, it becomes a question of whether the surrogate mother should be treated in law as primarily a contract-making or a child-bearing creature. (The situation is further complicated because on the one hand the prospective father is also likely to be the biological father, while on the other the prospective mother may have supplied the egg: there is thus no simple division between natural and social claims.)

In the case of foetal technology, the questions have to do with the way in which pregnancy comes increasingly to resemble a process scientifically controlled and regulated, with the possibility of rejecting a product found to be defective. Parents are faced with the obligation of choosing whether to continue with a pregnancy when the embryo has been diagnosed as likely to suffer from particular diseases. As the techniques for identifying genetic traits become more and more sophisticated, it becomes correspondingly both difficult and necessary to determine where the boundary should be situated between a major and a minor defect; dystopian scenarios envisage a world in which babies are 'quality-controlled' according to a kind of private eugenics, determining every last detail from sex to intelligence to hair colour.

In addition to more general ethical issues concerning the limits of technological interference or assistance with processes leading to birth, issues of class and money are also involved. Infertility treatments tend to be costly, which already imposes a boundary in relation to who gets access to them; but in addition to this, surrogacy – 'rent-a-womb' – involves the use of a woman's body for the duration of a pregnancy. If she does it for money (which is not illegal in some American states), there is likely to be an economic difference between her and the social mother-to-be, who is paying for her services;[10] it is also not clear how the appropriate wage might be calculated (most arrangements have been lump-sum agreements).

Opposition to paid surrogate mothering usually rests on the general prohibition of commercial dealings in bodies or body parts, but the large amounts of money involved more generally in the purchase of the new fertility treatments have been accompanied by a suspicion that 'the baby business' might be just another consumer industry, in this case for well-to-do young

professionals in search of the ultimate designer accessory to complete their life style. 'Are we headed for an age in which having a child is morally analogous to buying a car?' asks an article in *Newsweek*, and then quotes a doctor: '"I see people in my clinic occasionally who have a sort of new-car mentality. . . . It's got to be perfect, and if it isn't you take it back to the lot and get a new one."'[11]

What is interesting here is that the attribution of consumerly qualities, unlike the attribution of a language of individual choice, is assumed to be automatically damning. But as the next chapter will show, the psychological and social conditions of consumer choice are anything but obvious: the problem is rather in the way that consumer choice can come to function rhetorically as a category taken as being both simple – in need of no more discussion – and negative, if not corrupt. This also then has the effect of implicitly separating the choice to have children into two classes, the pure and the impure. If some people want babies the way they want cars, then somewhere else there are genuine parents-to-be, whose desires, whether rational or natural, remain untainted. In neither case, the genuine nor the consumerly, is the wish taken as requiring any further analysis.

But to the extent that consumer choice has itself become the dominant language of choice in the cultures which foster and adopt the new reproductive technologies, at once all-pervasive and highly indeterminate, it may be that the complexities in this area have something in common with, and something to contribute to, the debates about reproductive choice and the futures of human subjectivity. It may also be that the new kinds of reproductive choice inevitably share features with some kinds of consumer choice, which could fruitfully be explored. Instead of rejecting the consumer analogy out of hand, we might indeed consider the possible resemblances and differences between the desire for a baby, on the part of either sex, and the desire for a car or some other commodity. This does not imply any trivialization of reproductive desires (any more than it implies any particular reverence for car-buying). But in view of the fantasy structures involved in each, the comparison might turn out to be a way of highlighting different aspects of the wish for children than those that appear in the languages of individual rights or natural desires.

As a result of the continuing developments in technology, the

forms, possibilities and requirements of reproductive choice are changing all the time. The very availability of the various new methods of assisting conception and birth necessarily puts them forward as possible options to be considered for those who might want children. Thus changes in the conditions and types of choice are obscured by the apparent similarity of their derivation from scientific or medical innovations, represented as homogeneous, along a continuous line of progress. As in consumption, choice is no simple matter dependent on a pre-existing demand or desire, but is inflected, where it is not initiated, by what is available and what can be afforded. To say that reproductive choice now must bear little comparison to reproductive choice a century ago is not to question the continuity or the force of the wish to have children (or the wish not to have them), but to point to the mutability in the forms and determinations of choice, in this area as in others.[12]

There are also some very straightforward points of connection between reproduction and consumption. It is not just that wanting a baby might be likened to wanting a car or some other commodity, but that wanting a car (or a holiday, or a hamburger) has regularly been likened to wanting a child. (In this one respect, sexuality and reproduction, which were granted a provisional separation by contraception as well as by Freud, are curiously remarried in modern consumer culture: both are endlessly deployed as the most sure-fire methods of gaining attention for commodities.) Throughout the history of modern advertising (that is, for well over a hundred years), parental desires and anxieties have been used as a regular form of appeal to further the sales of almost anything; and recently, with the social and technological changes that have raised both the average age and the average income levels of new parents, consumption focused on parenthood as part of a 'thirtysomething' professional lifestyle has become a significant area of niche marketing.

The shock effect of the 'Benetton baby' poster – put up in September 1991 in European countries and almost immediately withdrawn in several, including Britain – is revealing in this context. The poster showed an unfamiliar image, that of a just-born baby, bloody, yelling, umbilical cord not yet cut. This baby is not pretty, and has no place (yet) in the consumer world which the advertisement, insofar as it is one, is none the less promoting (the words 'United Colors of Benetton' appear bottom left, partly obscured by a small image of a mother holding a baby, as though

to indicate the sequel). The outrage provoked by the image no doubt derived partly from the sense that it violated the purity of what is perhaps the only event that occurs outside or prior to a social world of consumption. In part, the poster was offering the crude message: this thing is going to need clothes bought for it. But at the same time, in showing the baby in a state of raw, messy nature, not sweet, cleansed nature, it was going against the commonplace imagery of the purity of the child.

As with the psychoanalytic conception of wishes and their objects, consumerly desires are also, as we shall see, represented by marketing theorists in terms of fantasmatic identifications: putting youself in the place of the one who wants to be this, or to have this. The kind of fantasy which involves a conventional imagery of babies and heterosexual couples in one sense demonstrates the tenacity of the traditional triangular pattern, even – or especially – at a time when the nuclear family consisting of two parents, one of each sex, and their children, is ceasing in practice to be the norm. This discrepancy is itself suggestive both of the lack of fit between fictions of identity and reality, and of the assumed demand for such synthesizing stories.

But in addition to drawing on standard symbolic constructions, marketing theories also work on the assumption that men, women and children (insofar as these are stable categories) are in fact highly mobile in their inclinations and their possible identifications (one example would be the exploitation of 'new man' images, from the narcissistic to the nurturing, promoting or appealing to the dissolution, not the continuation, of conventional gendered roles): any old story, or rather any new story, will do. Marketing psychology agrees with psychoanalysis that people both need and seek stories through which to give themselves an identity. But unlike psychoanalysis, marketing theories of human behaviour are not particularly exercised by the suggestion that some kinds of identification – as parents and as children, for instance – might be more fundamental than others. So if the old oedipal triangle were indeed collapsing, losing the sharpness of its corners and loosening the identities of its occupants, there would be no reason, from this point of view, why alternative stories should not come into being.

But there remains the stubborn fact that obsolescence, like adolescence, cannot always be planned, and that unlike children, cars and other objects of consumption tend not to rebel against

identifying with their owners' fantasies, whether or not they turn
out to fulfil them. Frankenstein, as we saw, was already imagining
the uncertain variables remaining in even the most perfect design
of a custom-built offspring. There is no way of knowing in
advance where the new baby will find its place – or what, if
anything (from cars to children to Benetton clothes), it will want.

Chapter 7

Make up your mind
Scenes from the psychology of selling and shopping

SCENE 1: THE UNIVERSAL SHOWROOM

To set the scene, and to gain your attention (all commentators are agreed that this is the first difficulty faced by anyone with any kind of proposition to put over), let me begin by quoting a grand evolutionary statement which culminates in the fulfilment of the characteristic twentieth-century mode of being. On the first page of a how-to book for prospective door-to-door salesmen published in 1927, there occurs the following passage which moves into realms far beyond the contingently practical:

> In a commercial sense, by 'selling' we mean disposing of or exchanging commodities for profit.
>
> Of late years, however, 'selling' has taken on another meaning. We are learning to recognize that nearly all human relations involve gaining attention, arousing interest, using persuasion. These are fundamental terms understood in the world of commercial salesmanship. The fact that they have been taken over into other phases of life besides those of commerce, indicates that the human mind is growing and broadening. We are beginning to realize that the act of living itself, in all its varied relationships, is, in reality, a vast business of selling and salesmanship.
>
> The woman who walks into a drawing-room takes care that her dress, words and manner shall please others she may meet there.
>
> The man who seeks admission to a club tries so to deport himself, and to impress his personality upon others, that he will be welcomed as a member of the organization.

In either case, the woman or the man is 'selling' herself or himself. That is a meaning of the word that has crept into the language and is readily understood by everyone. . . .
The young lover 'sells' his personality to his sweetheart; the wife, the idea to her husband of how beautiful she will look in a new fur coat.[1]

The passage both claims and exemplifies an expansion of terms associated with commerce beyond their original fields of reference, to take over new territories which are now seen to be their natural destination. A linguistic change covers and enacts a global change, as the wider meaning of 'selling' stealthily invades: it 'has crept into the language' to gain currency and purchase. All the world's a showroom, every man or woman is an advertisement for himself or herself, aiming to 'impress' and please his or her consumers. Two sexes are invoked with differentiated modes of behaviour – a man is wooer of women singly and men collectively, a woman a wearer of dresses financed by a husband, and so on – but these differences are subordinated to the overarching and organizing category of the scene of the sale in which both adopt their respective roles.

By the same token, everyone is also, in relation to everyone else, a consumer, taking in as well as giving off impressions; 'paying' or withholding his or her attention and interest. The primary aim of a book like *Salesmanship Simplified* – and there were numerous such books during this period – doubles up on its own argument: it is to sell selling – as a trade and as a way of life – to readers who are thereby addressed as consumers at the same time as they are being sold an identification of themselves as salesmen. This reciprocity also points to the way in which the generalization of 'selling' – the passage above self-consciously puts it in quotation marks, under exposure – was also, by the same token, the generalization of consuming. As another book of the period puts it from the other side of the transaction: 'The consumer is beyond economics, before economics, and beneath economics. For consuming is living.'[2] To the same degree that selling was becoming both a practical and a speculative theme, so was its natural opposite number. Viewed from the other side of the counter, consumption became the salesman's constant question: what will make this person buy? And it is for this reason that discussions of consumer behaviour, whether they emanate from within the

business world or from those who situate themselves outside it, tend to move rapidly and overtly into general questions of psychology. To know the conditions and workings of the mind is to know how to act upon it, how to make an impression.

There is an intimate connection, institutionally and intellectually, between psychology and marketing during the first forty years of this century and beyond. As psychology became separated off from philosophy on the one hand and neurology on the other as an independent discipline, the primary questions with which it was concerned were often identical to those that preoccupied advertisers, who wanted to know how people acted and thought in order to know what would get them to buy. Psychologists at this time were laying out areas of investigation which overlap to a striking extent with those that concerned advertisers from a pragmatic point of view; and the developing institutional fields known as 'consumer psychology' or 'the psychology of selling' form a bridge between the academic and the practical which makes science directly available to men and women engaged in selling, just as the interest of these professionals in psychological questions fed back, through actual funding and through other, less tangible channels, into the kinds of question that the 'pure' – not directly commercial – psychologists were asking.

Standard psychological topics at this time included the nature of choice and decisions, and how these might be affected by 'suggestion' as opposed to reasoned arguments; the distinctiveness of a collective or 'crowd' mind and how its operation differed from that of the individual mind in isolation; the differentiation between instincts given from birth and acquired habits, and the types of action to which each gave rise. All these are topics central to the consumer-orientated questions of marketing proper; and in this sense, the local questions about consumers become inseparable from apparently more general questions about the determinants and the nature of human choices and actions.

The output of texts about psychology and marketing at this time was vast, and their range encompasses every gradation from the academic to the popular. There are numerous books reporting on experimental and other findings for the benefit of those on the policy-making side of selling, but there is also a large body of 'how-to' books for prospective door-to-door salesmen, or department-store assistants, which include material on psychology and how to

use it in dealings with customers as a central part of their presentation. Considered from the perspective of the seller, it seems obvious that the issue of what makes a consumer choose to buy or not to buy, be it the sixty-four-thousand dollar or the seventy-five-cent question, stands alone. But in fact, as in the opening quotation in this chapter, large claims are made, in popular as well as academic textbooks, about the inherent interest of psychology, as well as about the capacity of consumer psychology to stand for psychology in general.

A 1921 handbook for department-store assistants puts it like this:

> In a retail store, you have a wonderful chance to study human beings. Don't you think it is interesting to look at men and women and to wonder about them? Who are they? What are their chief characteristics? Why do they act and talk as they do? Where are they going? For what purposes do they buy various articles?
>
> This does not mean that you must be 'nosey'. It simply means that as an alert individual you must study people.
>
> It is the most absorbing game in the world, even more interesting than reading stories or novels. You are dealing with all types of individuals. Each one talks and acts differently. Why?[3]

In the quotation from the salesmanship book, all the world is a showroom; and it would then follow, as stated here, that the showroom is a microcosm of the whole world. This world of the most accurate psychological evidence is explicitly a place of fiction – of games and stories. Where previously you might have learned psychology from reading, now you will get it, and it is 'even more interesting', from the customers in a store.

Walter B. Pitkin's post-Crash discussion of consumer psychology draws on a similarly literary analogy, obliquely making a case not only for the pertinence of classifications in psychology based on categories from imaginative writing, but also for the priority of the consumerly to the literary as a psychological paradigm. The author makes a distinction between 'romantic' and 'classical' consumers:

> It sounds silly to speak of consumers as displaying 'classic' and 'romantic' taste. Yet they do this, and in a sense even more

intensely than most literary critics have done. The ordinary person is, in this sense, a romantic through and through. His cravings . . . are many, relatively weak, not sharply organized around one or two dominants, and hence somewhat blurred both intellectually and emotionally. He may even find it hard to distinguish his ego from his cosmos.[4]

The difference between the two, and the tendency for the romantic to supersede the classical, is best exemplified for this book by the history of the automobile. Writers of this period, and particularly this one, Walter B. Pitkin, tend to see the motor car not merely as an example of a desirable commodity, but more or less as the epitome of the desirable commodity, their test case or test drive for how and why people might be moved to buy things. Pitkin continues:

The original Ford car was built on classic lines. . . . The vehicle had just one purpose and it fulfilled that better than anything else ever had; it aimed to transport its owner from point A to point B at a velocity never before attained with the same degree of safety and economy. It made not the slightest attempt to serve any other human wish; there was nothing of beauty in its line, still less in its color; it contained no cigar lighter, no mirror, no powder puff, no clock, no compass, no barometer, and no radio. It was the expression of a single-track mind which had solved a single problem. And that is the very essence of the classical. Ford did one thing at a time and did that with austere completion.[5]

The classical mind, for producer and consumer alike, is thus based on principles of utility, security and above all economy (in time, money and mental effort: only one track). In every way, it directs itself from A to B by the shortest possible route, whereas the romantic mind is all over the place in its one place, treating the car as a luxurious interior stocked with gadgets to suggest and satisfy every momentary hedonistic whim.

From Pitkin's miniature history of the classical and romantic versions of the motor car can be extrapolated two standard models of the consumer, which have been subject to relatively minor modifications over the years in discussions of consumption from outside the economic field itself. One – like the romantic – is the consumer as dupe or victim or hedonist or any combination of

these, infinitely manipulable and manipulated by the onslaughts of advertising; the other – like the classical – is the consumer as rational subject, calculating and efficient and aware of his aims and wants.

The first may be collectivized as the stupid population of a place called consumer society; such inhabitants are often seen as having undergone a process of what is called feminization: they are 'like women' in their capriciousness and hedonism, though without this necessarily implying that such characteristics are natural to women. The second type is collectivized as either a noble opposition to the blandishments of consumer society, as with advocates of co-operative retailing or subscribers to magazines like *Which?* or *Consumer Reports*; or, in a move which exactly parallels the extension of the selling model outside the technically economic sphere, as citizen–consumers.

Here I am thinking particularly of recent developments in Britain, where the word 'consumer' acquired a newly positive status in Thatcherite rhetoric. Before, people were students or patients or voters; now, they are consumers of education or health care or political representation, and the term implies an assumption of rights and initiatives which were by implication not available to the various characters identified with the separate terms. The 'classical' model is also, implicitly, the identity which makes the consumer the double of the strategic salesman as deliberate planner; or, in another regular permutation, the 'classical' identification may exist unacknowledged in coolly rational critiques of the manipulative powers of advertising. In a world where every other mind is assumed to be infinitely vulnerable and impressionable, the critic of marketing techniques has somehow alone succeeded in preserving the balance lacking in everyone else.[6]

The two types of consumer are complementary insofar as they turn upon a fixed opposition between control and its absence, between behaviour that is knowing and conscious of its aims and behaviour that is imposed on a mind incapable of, or uninterested in, resistance. A perfect accord, which is also a ready-made, and a custom-built, tension, exists between the passive and the active, the victim and the agent, the impressionable and the rational, the feminine and the masculine, the infantile and the adult, the impulsive and the restrained. The list could be continued through many familiar polarities, all of them easily taken up under the

aegis, or rather the label, of the two modes of that modern identity, the consumer. To be a spender or to be a saver: those would seem to be the two alternatives, and each implies a distinct view of the workings of the mind of the character dubbed the consumer. Advertising psychology is concerned with what the mind is in the light of the question of what will bring it to the point of purchase: in other words, with how people make choices, come to decisions. Because the emphasis is always on how minds may be moved, on how people change their minds, there is never any question of a static, self-contained consciousness, immutable and self-centred – and this applies as much when the mind is considered as operating rationally and in full knowledge of its aims and wants. A different form of persuasion or motivation will be appropriate in this case, but the rational mind, or the mind in its rational mode, is considered to be no less subject to influence or sollicitation: it simply has to be persuaded that its wants are not whimsical but sensible.

SCENE 2: MAKING UP THE MIND

'To most women', says Ruth Leigh, addressing prospective department-store assistants, 'making up their minds is a difficult and unpleasant task.'[7] The phrase beautifully summarizes the ambiguities of the consumer situation or – and it amounts to the same thing, as we shall see – of the enterprise of psychological description. In a moment, we shall be examining just how this making up of minds was supposed to occur – by what stages, and in what order of events. But even in its initial formulation, the standard phrase is as suggestive and multivalent as the process it supposedly puts a stop to is complex and indeterminate. To make up your mind is to come to a decision; but that 'making up', especially when openly assisted by another party, seems in all kinds of ways to detract from or make problematic the exercise of independent reason that the phrase initially seems to indicate. Let us look in more detail at four of its possible meanings.

To make up is first, to supply a lack, as in phrases like 'to make up the difference', 'to make up for lost time'. There is something missing from what would otherwise be complete; an implicit subtraction is rectified. But a second kind of making up is almost the opposite of this one: to make up a face is to add something to

it, with a positive connotation of enhancement or adornment where the first kind of making up merely involved the avoidance of something negative. These two modes of making up correspond, roughly but readily, to the classical and the romantic consumer: to the mature, masculine saver determined to avoid a loss and the infantile, feminine spender, unregulated in her desires. In terms of the forms of advertising address, the first mode involves the suggestion of fears or needs. The buyer must identify himself as lacking and so purchase the product in order to put things right or protect what is vulnerable. The second mode is in the form of an invitation to pleasure or excess: to have or be something more, something else, something new.

Classically, and romantically sometimes, forms of marketing address which are making an 'emotional' appeal (as opposed to an appeal to the consumer as a man of sense) can be divided between these two modes: the warning (look what you lack) and the promise (look what you can have or what you can be). In the first case there is a threat to an implicitly attainable or former integrity which you risk losing; this may take the form of physical appearance or social standing, or both. In the second, there is the hope of a rise or a raise or a pleasure that you do not at present enjoy, in the context of a mobility that may be upward or merely unfixed, and is not predicated on a given identity or wholeness to be either restored or achieved.

In a third sense, making up implies putting together from pieces: an advertisement or salesman works to co-ordinate, bring into an ensemble, a mind that would have no being or direction without this integrative or unifying intervention. The decision to purchase, in this sense, parallels the effect which the product is supposed to procure, by marking a provisional moment of settlement and unity. We shall be returning to this moment of the sale – a moment which must always be anticipated, as we shall see, but which it is only possible to locate retrospectively.

There is also a fourth and crucial aspect of making up your mind, which is its buried connotation of fictionality. To make up is to invent. The seller makes up the mind of the buyer, casting her (it is generally her) in a role and giving her an ideal script to go with it. By the same token, the seller also puts himself (it is generally a he) in a role, plays a part and makes up a mind to the same extent as the buyer.

This process of making up and acting out is described and

prescribed in great detail in the early texts of salesmanship practice and consumer psychology. These accounts of buyers' minds and selling processes shift the emphasis away from a choice between two different, and potentially incompatible, psychological models, since they involve an overt dramatization which implies that neither is seen as being fixed or there from the start for either protagonist, though notions of fixity can be a frequent source of appeal. There is a give and take, a to and fro, an *exchange* in all senses, in which both consumer mentalities are simultaneously implicated, and always open to modification or reversal.

In order to take a closer look at these issues, I propose to concentrate on a particular preoccupation of these texts – the step-by-step process that is supposed to lead up to any decision to purchase. This provides a particularly sharp illustration of the ways in which representations of consumer psychology and selling psychology 'on the ground' – in the shop or the house-wife's home – may illuminate and complicate what looks like the simple dichotomy between rational and non-rational consumers or, by implication, between rational and non-rational human beings.

I have two other selling points. First, as the idea of the classical and romantic consumer will already have suggested, there will be more to say about the relations between consumption and litera-ture. And second, since this is also the period when another new kind of psychology was developing – a specialized Austro-German import which allegedly suffered in transit and got standardized for the American market – I will also, at the end, be drawing together some questions about the scenes and structures of psychoanalysis's version of the mind which these excursions into the mall may have suggested.

SCENE 3: THE PRIEST, THE JUDGE, THE SOLDIER AND THE LOVER

So let us now proceed to look more attentively at the step-by-step process of this remarkable performance, the sale. That it is a drama, in the full, theatrical sense, is made explicit by the constant use of this word in presentations of the method of selling; one book, for instance, has a whole chapter on 'Dramatization'.[8] Salespersons are to think of themselves as acting a part and as

endeavouring to carry a performance through to a happy ending, with attention at every stage to the 'cues' from the prospective buyer. Here is one example, from *The Mind of the Buyer*, a 1921 theory book for practitioners in the field by Harry Dexter Kitson:

> Stage the sale so that there will be no disturbance while it is in progress; for any disturbance, no matter how trivial, may mean the introduction of a new idea into the mind of the buyer and a dislodgment of the balance of brain energy. In view of such danger, the salesman should carefully isolate the buyer and separate him from things and people. This is the great psychological advantage of using a show room.[9]

The ideal, then, is a situation sealed off so that nothing can make its way into the buyer's mind but what you, the salesperson, put into it or make up for it. Script and props alike should be kept under strict control.

The process of the sale is compared to a number of paradigmatic stories according to a number of distinct stages. First, the stories, of which there are four: each is used as an example, a model for sellers to follow, but also, at the same time, subsumed as no more than an isolated and possibly anachronistic species or branch of selling, which is the general store of all verbal and non-verbal forms of persuasion. The story of the sale, and the practice of sales talk, are the latest modes, and also the mode to end all modes.

The first comparable story is the religious conversion. This example is from Kitson again:

> For an excellent example of the tactics to pursue at this stage [the matter in hand is the sale of tires] the seller may profitably study the methods used by a professional evangelist in 'selling' religion. He begins by showing the prospective convert (buyer) how great a lack there is in his life.

The same book draws also on the second of these paradigmatic scenes, which is that of a trial:

> The situation at this point may be likened to a court-room scene in which evidence is submitted and arguments are presented for and against. As each bit of evidence is submitted, the judge (buyer) must test it.[10]

Unlike every other identification, the courtroom scene casts the

buyer–judge as a rational adjudicator; in all the other three cases, though in very different ways, to buy is to be overcome – without reason.

The other two model narratives are the commonest and the dominant ones. One of them, the military paradigm, surfaced in the allusion of the quotation above to the 'tactics to pursue'. This one is all-pervasive in the idiom of salesmanship, written in as it is to the language of every advertising 'campaign'. The buyer, or the market (for this model lends itself also to discussions of selling to groups), is an enemy whose resistances must be overcome in a battle which ends in its capitulation.

Equally charged, and equally central, is the last of the four selling stories: the scene of seduction. The seller approaches the buyer with blandishments designed to lead her (or him) against or in spite of whatever will to resist she or he may have, to pay the price and bestow the final favours as ultimate consumer. This paradigm tends to be closely intertwined with the previous one in accounts of the likely progress of events between seller and buyer, to the point that it is practically impossible to separate one from the other. But military and erotic scenarios in any case have a long history of overlapping, as object of desire and object of attack coalesce in the 'victim' of love's wound or a lover's onslaught.

SCENE 4: THE SCENE ITSELF

Let us now turn to the detailed unfolding of that quintessential twentieth-century psychical drama, the sale. For as with all narratives – or so a brilliant purveyor of literary mythologies once led us to believe – while there may be numerous subgenres and thematic variations (in this case the battle, the seduction, the religious conversion and the trial), there is a certain structure to which they all, in their different ways, conform.[11] The sale is classically represented in four romantic stages; for what it's worth, they were invented by one E. St Elmo Louis – 'in about 1898', as my source intriguingly puts it.[12] The four stages, given in terms of the mind of the buyer or 'prospect', are: Attraction, Interest, Desire and Sale – or, more logically, Action. From the point of view of the seller, the two outer stages are known as the Approach and the Close. There may be narrative expansions, overlaps and delays in the laying out of the sequence: Kitson, for example, slips in 'Confidence' after Desire, and tags on 'Satis-

faction' at the end[13] – but basically the outlines do not change. If you open an introductory marketing textbook today you will still find the four stages there, though they are likely to be rapidly abandoned amid a passion-killing barrage of econometric data. The first stage, attracting attention, is by common agreement equalled in difficulty only by the final 'close'. It is upon these two, the beginning and the end, that I am going to concentrate, leaving out all the infinite delays and diversions which are possible in the interim, be they pleasurable or frustrating. Not that interest is boring, or desire unattractive; but for the moment we only have time to deal with the principal selling points. Occasionally, indeed, so the literature tells us, there really is little more to it than a happy conflation of the start and the finish:

> In some instances it may happen that both individuals simul-
> taneously experience the impulse to exchange and in perfect
> unison pass through the various stages leading up to the final
> act of transfer of ownership, without either exerting any influ-
> ence on the conduct of the other.[14]

But these wondrous coincidences are really no more than the perverse exceptions which prove the rule of normal difficulties. We will begin, then, with stage one: attracting attention. In a common representation, derived from the psychology of William James, the mind is represented as a constantly flowing stream of consciousness; the seller's first task is to succeed in throwing in his or her commodity, or rather the idea of it, so as literally to make waves, to make an impression. Discussion of how to play this first moment – what one book calls 'the method of arresting and penetrating the mental stream of the buyer'[15] – brings in funda-mental questions about the mind's dispositions, and how they operate in relation to what comes their way from the outside. These dispositions are usually divided into the natural and the acquired, or instincts and habits. Kitson lists a number of stimuli which will naturally cause the mind to turn its attention to the proffered idea. These include repetition (say it often; the power of the trade name); extensity (big billboards are good, and for some reason 'Americans as a people are almost obsessed by the idea of immensity. They regard it as practically a virtue in itself'[16]); intensity (especially a loud noise which will shut out all the rest); colour; and movement (the cinema is the chief example here, but the car, as always, is often cited too).

If the approach is made by a man rather than by an ad – if, as one book puts it, you 'call in person' rather than 'call in print'[17] – different tactics apply, and these in turn depend on whether you are in a store or whether you are trying to cross the threshold of a private home in order to make your 'demonstration'. In particular, when the buyer is in a store, or leafing through a magazine, s/he can be supposed to be expecting and open to an approach, which is not the case when a salesman simply rings a doorbell and tries to barge into a housewife's hallway or stream uninvited. There is a running or at least ongoing argument between advocates of personal selling and selling by other means; Henry Foster Adams, an advocate of the second, unequivocally relegates the man to the status of an unreliable advert, since the latter 'never gets sick' and can work 365 days in the year.[18]

Before moving on to the next stage, we may pause on the bank or the doorstep to look at a nice literary evocation of an approach which half succeeds, but ultimately fails to take hold. Inevitably, it has to do with cars. In Virginia Woolf's novel *Mrs Dalloway* (1925), Peter Walsh, on leave from a post in India and newly involved with a woman there, has just been to visit Clarissa Dalloway, with whom he was in love thirty years before. The 'prospect' is on foot, walking the streets of the city in that state of unfocused attention from which an 'approach' will have to recall him:

And there he was, this fortunate man, himself, reflected in the plate-glass window of a motor-car manufacturer in Victoria Street. All India lay behind him; plains, mountains; epidemics of cholera; a district twice as big as Ireland; decisions he had come to alone – he, Peter Walsh; who was now really for the first time in his life in love. Clarissa had grown hard, he thought; and a trifle sentimental into the bargain, he suspected, looking at the great motor-cars capable of doing – how many miles on how many gallons? For he had a turn for mechanics; had invented a plough in his district, had ordered wheel-barrows from England, but the coolies wouldn't use them, all of which Clarissa knew nothing whatever about.[19]

The appeal made by the cars displayed to the passers-by meets a response, to the extent that Peter Walsh's reflections turn towards scenes of grandeur, immensity and performance. The image of the car has elicited from its spectator an appropriate accompanying fragment of what advertisers at the time were

calling 'reason-why' copy, as though he is spontaneously taking on the role of the consumer addressed as interested in fuel economy. But in the conflation of miles per gallon, colonial power and the size of the Indian subcontinent, it is not the propositional situation of the car shown in the window which comes to the front of the reflections in his own mind. Superimposed on the car, he sees the enlarged image of 'this fortunate man, himself', his own technical expertise and decision-making authority in the vastness of India among its inferior inhabitants; at the same time this puffing up of himself acts as an accompaniment or background to the insistence on being in love now and uniquely, and thus not with Clarissa, who is explicitly and repeatedly put down or put out of the way, but who in fact, and precisely through this contrary effort, floats so visibly in the syntactical stream of these thoughts. Psychic processes are prompted by those of the window display's mode of appeal, which claims his attention but not enough to make its own features take over from those that derive from Peter's personal story.

SCENE 5: THE MOMENT

In the *Mrs Dalloway* case, the approach fails: a moderate attraction fails to develop into the positive interest of the second stage, let alone to the desire that is a prelude to purchase. But we will move on none the less, to see what happens subsequently if the buyer's attention is successfully secured. As though encountering no impediments, we may skip past interest and desire to reach the grand finale of the drama.

Everything in the final, crucial stage depends on gauging and acting on an elusive something called 'the moment'. The discussion of the moment looms large in both the practical and the theoretical discussions of selling; and just as selling can be generalized to encompass all facets of human psychology, so the moment of the close becomes nothing less than the key to explaining every change, every event, in human history, individual and cultural. Here is one account:

> The 'psychological moment' is not confined to the business of selling. It occurs in all kinds of human relationships, from such relatively inconsequential affairs as the feeding of a baby, to such momentous events as the precipitation of a World War. It

occurs when the astute evangelist feels it proper to urge his hearers to hit the sawdust trail and when the seducer feels that he may, without fear of rebuff, press his victim to take the first drink.[20]

The writer goes on to quote Shakespeare, an early marketing theorist it turns out, who 'referred to it in the well-known lines: "There is a tide in the affairs of men,/Which taken at the flood, leads on to fortune"'.[21] It is in fact common for writers on consumer psychology to bring in literary examples as proof or illustration of their psychological arguments. Shakespeare is frequently cited, but so are a whole range of other authors, from Coleridge to Twain to the ubiquitous Ben Franklin.

Following their lead, we could turn to more contemporary literary comparisons, for instance *The Picture of Dorian Gray* (1891). Here is the aristocratic dandy, Lord Henry Wotton, measuring his effect on Dorian, the innocently suggestible prospect, to whom he has been 'talking up' the beautiful portrait of him that has just been painted: 'With his subtle smile, Lord Henry watched him. He knew the precise psychological moment when to say nothing.' And later on, the 'psychological' reference is made precise and authoritative:

There are moments, psychologists tell us, when the passion for sin, or for what the world calls sin, so dominates a nature, that every fibre of the body, as every cell of the brain, seems to be instinct with fearful impulses. Men and women at such moments lose the freedom of their will. They move to their terrible end as automatons move. Choice is taken from them.[22]

In a somewhat exaggerated form – the psychology of advertising tends to replace the vocabulary of sin with blander invocations of transgressive behaviour, such as 'wicked' perfume, or cakes that are 'naughty but nice' – this is an exact description of the result aimed at by the salesman. The moment of choice, of the exercise of the will, is in fact a relinquishing of the will; the whole task is to get the prospect to the point of capitulation, when there is no longer any question. Action is then spontaneous, irresistible; the mind has become purely biological or mechanical (the automaton).

In *The Mind of the Buyer*, with the same physiological emphasis as in Wilde's references to fibres, cell and brain, Kitson puts it like this:

[In] employing the power of suggestion, we attempt to insert some object (whatever we have for sale) more or less abruptly into some person's mental stream. . . .

The next event – the production of muscular efforts – is more difficult to describe, and to achieve. It is here that the greatest amount of mystery centers; and here that the greatest amount of skill is demanded of the seller. How can a psychical thing like an idea change over into physical energy and assume the form of a motor act? And how can the seller facilitate such transformation?[23]

The 'mystery' of the sale is all focused on this final 'conversion' – successful persuasion as the changing of impression to expression, of the psychical idea into the physical act. One technique for obtaining it is to assume that you already have: for instance, by asking about the preferred means of delivery, or passing over the order book for signing. Tell-tale physical signs may be studied in the form of 'small involuntary movements'.[24] But the changeover can only be registered in its effects, so the skill is to pre-empt it by taking the moment to have happened already. There is no plain sailing or plain sale; the point of making the decision is the point at which both control over actions and mental conflict – a tension between ideas – are eliminated.

SCENE 6: A CUSTOMER IS BEING BEATEN

All commentators agree that, as *Salesmanship Simplified* puts it, 'The close is the climax of the drama you have enacted with your prospect. Make it the big moment, as the climax of a drama deserves to be.'[25] It is regularly described as 'consummatory'. But it remains nebulous, unassimilable to the structure. Appearing only at the point of its having been passed, the moment signals this fine barrier between the two, after which there is no going back – but also, potentially, nothing to do, no movement at all. So once the moment has come – once back across the threshold or outside the show room – what happens next? What is this thing called consumption?

In fact, it turns out that the close is by no means the end of the story: the drama is successfully concluded only if it leaves behind the anticipation of a repeat performance, and for this it is necessary that the prospect feel that she, not the salesman, has won:

She will be a booster for you because she believes she hasn't been sold, but has forced you to give her the best of the deal. . . . While a woman, easily sold, will forget about you within a half hour after you leave her home.[26]

Both buyer and seller, then, should imagine that the choice was theirs, and by the same token that they have triumphed over the other. Ruth Leigh counsels implicitly against the roll-over-and-fall-asleep mode of post-close behaviour:

> Remember this point: to maintain a customer's patronage permanently you must remain as interested and attentive to her after the sale as before. . . . The most valuable advertisement any store can have is a customer who departs in a pleasant frame of mind, thinking: 'Well, that saleswoman *must* have been interested; she tried hard to please me.'[27]

You have to ensure that the customer will be coming back for more; the only criterion of a sale's success is that it will generate another sale and another. This means that the question of consumption itself – whether the product fulfils its promise or answers the supposed need or wish, how it is used or used up – is altogether left out of count in a drama which subsists, or rather profits, entirely by its own momentum and its own imagined climactic moments (satisfaction? forget it – or rather, seek it, again and again).

SCENE 7: WINDOW DRESSING

So now there is nothing left but to rerun, or repeat, the whole routine in terms of another mind that has to be made up in a different way: that of the seller. In a section headed 'Finding a point of common interest', *Salesmanship Simplified* goes back to the beginning and makes it much more complicated than it seems to outward appearances:

> Now, 'the approach' is not exactly the physical act of walking up to the door and greeting a prospect. It is really the approach of your mind to hers. And though you oppose each other when excuses or temporary objections are made, you must find some common point of interest upon which your minds can meet. . . .
> Create the impression that you are considering her interests above yours.[28]

The subordination of the physical setting to the mental one, literally a case of mind over matter, fits with the artifice of the 'showroom' scene, where nothing extraneous must be allowed to intrude upon the mind of the prospective buyer. The 'meeting' is of minds set apart from the environment in which it happens to take place. As we have seen, the process leading up to the point of purchase is invariably represented in the form of a mental story with a supposedly physical end, or a fantasy that culminates in a hypothetical real event: it is a question of making a mark or an impression on a mind, such that something that looks like action, in the form of the decision to purchase, can be seen to have ensued.

Detailed instructions about how to orchestrate the performance occur in Ruth Leigh's book, *The Human Side of Retail Selling*, which is addressed primarily to women department-store assistants serving female customers (interestingly, in 1921 she uses the word 'salesperson' and the generic female pronoun throughout). It includes clear advice about how to present yourself, in every sense, to the customer: how to make an introduction and how to appear. On the question of 'Your expression', for example, Leigh says:

> [Y]our expression must be an indication of your attitude and personality. . . .
>
> No matter how tired you are, smile pleasantly at the approach of a customer. Do not smirk or give a bored smile of duty, but smile in a sincere, engaging way that will make a customer feel that she is welcome in the store. Unfortunately, however, salespeople's smile can be overdone; they can make or break sales.[29]

There is a finely drawn lipline here between not enough (too tired to smile at all) and too much (the 'overdone' performance). The right kind of smile is expressly put outside the category of 'duty'; it should be a sign, or 'indication' of both your real nature and your present disposition ('your attitude and personality'). The expression that truly expresses what you are and what you are feeling is thus also a double act. The duty smile is a first level of acting whereby actual tiredness is overlaid with simulated warmth; it is recognizable as a sign that points to something other than what it is, and incompatible with it. The correct smile, in contrast, is literally beyond the call of duty, responding to the

even more stringent demand that the smile be in accord with what it suggests ('Your expression *must* be an indication . . . ').

This is a version of the double-bind instruction familiar in much popular psychology of the period, notably Dale Carnegie's *How to Win Friends and Influence People* (1936), whereby on the one hand you have to work at looking as though you are sincere, but on the other hand you will only succeed in this if you are sincere in the first place: the exhibition of sincerity, acted out, becomes the sign of its naturalness, making up as completion rather than artifice.

Leigh lists six types of smile 'in which salespeople mistakenly indulge' (the pitying, the sarcastic, the knowing, the idiotic, the bored and the 'heaven-help-me'): every disposition that is not the appropriate one is subject to a classification that renders it typical and impersonal, not 'you'. This corresponds to parallel classification of 'types' of customer, which the salesperson should learn to recognize and to deal with accordingly. The chapter on types of customer goes through no less than nineteen of them, ranging from 'The Bargain Hunter' to 'Mother and Daughter Customers' to 'The Customer "Just Looking Around"' to 'The "Nosey" Customer', and so on; and concluding with a couple of paragraphs wearily headed 'Each Customer a Problem'.[30]

Here too, as with the salesperson herself, it is not just a matter of judging from appearances: part of the 'problem' is to assess whether your customer is merely acting the part of some particular character which may not be her true one after all: 'The aloofness of customers is often a pose to mask their attitude toward the merchandise.'[31] In this respect, the customer has become a salesperson too, and the pair are matched as equals, each of them acting in order to create a particular 'impression'. Any distinction between the appearing and the hypothetically real self fades away, since every characteristic, of buyer or seller, can be classified as one of a fixed set of types, and put on or off according to the situation. The strategy for maintaining the upper hand, for out-masquerading the fellow *poseuse*, is then a simple one: put yourself in her place: 'Consider the approach from the angle of the shopper, and you will appreciate it more fully'; 'Present goods from the customers' angle by picturing their needs. Talk in terms of "you", not in terms of your store or its merchandise.'[32]

A similar call for conscious identification occurs for the door-to-door tactics of *Salesmanship Simplified*:

The best way to discover whether you are being turned down because you do not make a favorable first impression is to stand in front of a mirror when you're ready to start out and scrutinize yourself carefully.[33]

No more is said; the assumption is that you can see yourself as you will be seen, and whatever it is that is making the negative impression will do so also upon the you that is now looking at you, who for this purpose is someone else. The business of identification to the point that you know exactly what your customer is looking for and looking at is then the logical next step, as the salesman evaluates himself from the position of the prospective buyer, the recipient of the impressions he makes or fails to make. He will thus become his own consumer, first – in the impulsive, malleable position – identifying himself with the one who takes the impression, and then, in a second moment, rationally evaluating the means by which it has been produced so as then to adjust it if necessary.

And as if in response to this demand, manuals for budding salespeople always include a section on what is usually called 'self-development' or 'personal qualifications', in addition to the section on the psychology of the consumer. The self-development section is literally about how to get your act together. In this regard, the seller treats himself as capable of taking on, taking in, new goods, in the form of new good qualities, in the same way as a customer; the objective is to fit yourself out with as many positive features as possible, which can then be utilized – put forward or promoted – in the appropriate situation.

What this then implies is that the seller's mind itself becomes a shop, or shop window, stocked with ideas and dispositions to be brought out and displayed when required, to attract attention or make a favourable impression. One early textbook of 1911 puts it especially clearly, heading its introductory section 'Inventory of Qualities', and continuing: 'Business success requires inventories of the mental stock as well as inventories of the business stock. These mental inventories show what qualities a salesman possesses and in what qualities he is deficient.'[34] You should be constantly building up your stock, by means that range from reading to exercising to studying other subjects (Leigh's advice to store assistants is to learn psychology from looking at customers). Consumer and salesman have thus come full circle,

interchangeable in their shared perpetual quest for the appropriate personal display in what has been identified as a world of generalized salesmanship: you buy the better to sell; and in selling you put yourself in the place of, identify with, the buyer.

SCENE 8: THE ULTIMATE SCENE

Now that the main business of the sale has been achieved, I would like to suggest one or two lines of development which may be opened up by this preliminary exploration of the drama of the sale. First, I have hinted throughout at points of correspondence between the psychological models used by early writers about the selling process and those of Freud, who is their contemporary. There is, in fact, something called the 'Freudian' model of the consumer that is still invoked in marketing textbooks. Its history goes back to this period, and it is extrapolated from a possible understanding of one aspect of Freud's thought – the unconscious and the role of instincts and defences. This Freudian model of the consumer vies with three others: the Veblen model, in which an instinct for prestige is seen as primary; the Pavlov model, which stresses the automatic nature of responses to certain types of stimuli; and the Marshall model which, in identifying the consumer's mind with that of a rational entrepreneur, saving costs and making calculated choices among options on the basis of all the information available, is the precursor of Margaret Thatcher's citizen–consumer or the intended reader of *Which?* or *Consumer Reports*.

But my point has to do less with the particular representation of psychoanalysis in marketing theory than with the ways in which Freud's own writings, looked at through the lenses of consumer psychology, might be seen to be offering another version of the modern marketing mind. It is a commonplace to talk about the 'economic' model in Freud, but this is never, as far as I have seen, put into relation with either the economics of his time or the psychological preoccupations of that economics in the area of marketing. The starting point for looking at this would be the whole framework within which psyches are seen by Freud to function according to principles of value, cost and saving, of exchange, investments, compensation, promises of satisfaction, incentive bonuses, and so on. Sometimes this involves trade-offs between rational buyer and rational seller, as when (in the text on

Jensen's *Gradiva*), repressed wishes are said to 'purchase' (*'erkaufen'*) their entry into consciousness in dreams, by means of distortions and disguises.[35] But everywhere in Freud, psychical modifications occur according to quantifiable criteria of gains and losses: you pay your way, and changes occur only 'at a cost', 'at a price'.

Alongside this recognizably rational psychic operator – a *homo economicus* of the classical sort – is a polymorphously hedonistic, romantic part, untroubled by any sense of duty or obligation to defer its gratifications. Pleasure (or else, the restoration of equilibrium) is the aim, through the transformation of a psychical wish into a physiological action, but it can be interfered with in innumerable ways. There is a drama of attractions and interests, desires and choices, in which minds are forever seeking and forever failing to acquire the object that will satisfy their longings once and for all. The choices and wishes of love appear in the same linguistic guise as those of consumption: one of the words used in relation to object-choice, for instance, is the verb *auszeichnen*, which is primarily used for selecting something in a shop.[36]

Or take that much-told story of the discovery of sexual difference – in particular, the one about the girl who sees something she instantly realizes she hasn't got, and wants it; who reduces her valuation of her mother when she realizes that she too hasn't got it; and so on. The question is how this logic of comparison shopping and impulse buying can seem to make sense – both as an argument, and in psychic terms. This is related to the way that motivation in Freud tends to proceed, as does the logic of salesmanship discussed in relation to 'making up', according to instances of threat and promise: threat of the loss of an imagined wholeness, or promise of the restitution or acquisition of something presently absent. This distinction is often drawn by sex, so that the girl, repeatedly, is said to 'cling to the hope' of acquiring what she feels she has been deprived of, while the boy is threatened by the loss of what he believes he already has.

Another strand of Freud is concerned with artificial settings and stagings. That 'other scene' of the unconscious, *ein andere Schauplatz*, is literally 'another showplace', identical to the showroom of consumption sealed off from the details and interferences of reality. In the discussions of fantasy and identification, there is always a dramatic structure involving reversible poles of identity, and the 'scenes' of fantasy involve mutually dependent and

oscillating positions: masculine and feminine, active and passive, voyeur and exhibitionist (the looker or consumer and the one on display). As with the dramas between consumer and seller, there is no fixed identity. The adoption of one position is always premised on the suppression and possibility of the other.

The analytic situation itself is another artificial scene, and one in which two participants play out a complicated set of roles in relation to one another. And in the same way as in the process of the sale, though over a much longer period, an analysis has to do with coming to a moment of decision or recognition which in itself is shrouded in mystery. In the course of his case histories and his discussions of analytic technique, Freud frequently remarks on the uselessness of the analyst's seeking to persuade the patient by rational means of his version of the story. The patient must realize the truth for herself; but this moment of 'conviction', how or why it occurs when it does, retains, like the 'moment' of the decision to purchase, a quality of unpredictability, even though it is the crucial turning point on which the success of the analysis hangs. The analyst may offer hints or suggestions, but in the end, the patient has to come to accept the interpretation for herself, to adopt it as her own: she must not experience it as something introduced from outside, imposed on her. At another level, just as salesmanship experts will say that judging the moment of the sale is a matter of practice and intuition which cannot be rationally learned or taught, so Freud, when dealing with standard objections to psychoanalysis, will regularly end with an appeal to the experience itself as the only criterion that will settle it: in both cases, you have to have been there, and as with the moment, there is thus a magical, indefinable quality to the decisive turning point.

In making these comparisons, I am not suggesting that psycho-analysis is to be equated with consumer psychology, or that the texts of consumer psychology have the complexity of Freud's. Marketing was never meant to cure anyone of anything, and if Freud had only wanted to maximise profits or patients, he went about it in a rather complicated way. (None the less, he has often been accused of being nothing but a salesman.) But nor does the interest of consumer psychology lie simply in the provision of a bit of cultural background the better to set off what is distinctive about psychoanalysis. To make a distinction between on the one hand a popular, commercial psychology with its limited interests and crude aims, and on the other an authentic, original and more

generally applicable psychoanalysis is already to beg, or sell off, the question by assuming that the consumer-orientated aspects of modern minds can be separated off as secondary, contingent formations. The point has rather to do with different kinds of question about the general devaluation of consumption as obvious – we all know what it is – and as secondary to more serious or complex concerns. For if the consuming-selling mind really is a dominant paradigm for the way we think psychology and it thinks us, then there is all the more interest in looking at how it is situated or played out within what is arguably the richest account of the mind that has appeared this century.

The type of opposition in which consumption is both subordinated and taken as in need of no further explanation operates in other intellectual areas as well. In literature, the most disparate critical figures agree on dismissing a kind of reading they associate with 'mere' consumption in favour of another kind which – for want of a less commercial phrase – is the genuine article. I am thinking here of obvious examples like F.R. Leavis, but also of less obvious ones like Roland Barthes. Barthes is not someone readily associated with hostility to mass culture – *Mythologies*, after all, while linking it to a delusive ideology, is all about its fascinations, about the importance of analysing how the seductions of consumerism operate. But at other moments, when he is not writing directly about consumer culture, Barthes too tends to use the notion of consumption as a given, and as a negative term in need of no further analysis.

In the much read essay 'From work to text', for example, he makes a distinction between the work as an 'object of consumption' and the text as something else. He goes on: 'The Text (if only by its frequent "unreadability") decants the work (the work permitting) from its consumption and gathers it up as play, work, production, practice.'[37] 'Consumption' here is almost literally the dregs; the use of the word 'decant' draws out one of the supplementary meanings of *consommation* in French as what you drink in a bar or café. The speedy, automatic and above all simple nature of consumption is being used as the contrast to everything valuable to be found in what may be left over when you have consumed. Or to take another example, a famous quotation from the start of *S/Z*, where Barthes is contrasting serious reading with cheap seriality: 'Those who fail to reread are obliged to read the same story everywhere.'[38]

What interests me is not so much the opposition of value in itself, though there would be much to say about this, as the way that consumption is able to function as the simple straw term against which the positive term can take its meaning and its value. And indeed it could be argued that the very deployment of consumption as the category of comparison makes the proof of its significance, for it implies not only that we all know what it is, but that it is something so common, so ubiquitous and so constant, that it can serve as the general background against which to set what is valorized as out of the ordinary, in this case reading.

A different approach to the comparability of literature and consumption occurs in this passage from Ezra Pound's *ABC of Reading* (1925). He is talking about criticism and taking an etymological line, pointing out that the Greek word from which it is derived has to do with choice:

> *KRINO, to pick for oneself, to choose.* That's what the word means.
> No one would be foolish enough to ask me to pick out a horse or even an automobile for him. . . .
> If you wanted to know something about an automobile, would you go to a man who had made one and driven it, or to a man who had merely heard about it? . . .
> Would you look at the actual car or only at the specifications?
> In the case of poetry there is, or seems to be, a good deal to be looked at. And there seem to be very few authentic specifications available.[39]

Consumer choice is here being used as the analogy, not as a debased subspecies, of literary choice. It is assumed that the process of coming to a purchasing decision would be the one which the reader will have most knowledge of; that it is a complex and reasonable process; and that the example of this kind of expertise should function as a convincing argument for the kind of expertise to be acquired in the matter of another kind of picking out, in relation to poems. The passage may be understood as Pound's advertisement for poetry-reading, and it is made classically rather than romantically: the appeal is not to a consumer likely to be rapidly seduced by some chance fancy, but to one who gathers together all the information relevant to a purchase which is planned in advance.

Pound's pitch does not imply any detraction from literary value or complexity, but nor does it take consumption as read. When we

wonder whether we 'buy' an argument, we acknowledge – and conscious irony does nothing to diminish this – that selling and consuming are inseparable from the modes in which modern minds think or speak themselves. As the elaborate psychologies of self-advertisement and the selling process indicate, there is nothing outside the shop – but this is something which, in all its everyday banality, we should perhaps not just take or leave as a given. We should 'pay' some attention to our surroundings and notice them for what they are – otherwise we will find ourselves entering the same shop every day.

Notes

1 INTRODUCTION

1 Aldous Huxley, *Brave New World* (1932; rpt Harmondsworth: Penguin, 1970). All further references will appear in the text.

2 PROMOTING DORIAN GRAY

1 Oscar Wilde, *The Picture of Dorian Gray* (1891; rpt Harmondsworth: Penguin, 1973), p. 91. All further references will appear in the text.

2 Other recent work exploring the parallels between aesthetes and consumers in literature includes Jean-Christophe Agnew's essay on 'The consuming vision of Henry James', in Richard Wightman Fox and T.J. Jackson Lears (eds), *The Culture of Consumption* (New York: Pantheon, 1983); and Rosalind H. Williams's chapter on Huysmans' character Des Esseintes, in *Dream Worlds: Mass Consumption in Late Nineteenth-Century France* (Berkeley: University of California Press, 1982). Since the writing of this essay in 1985, a number of invaluable studies of both sexuality and consumption in Wilde have appeared – in particular, Ed Cohen, 'Writing gone Wilde: homoerotic desire in the closet of representation', *Proceedings of the Modern Language Association*, vol. 102, no. 5 (October 1987), 801–13; Jonathan Dollimore, *Sexual Dissidence: Augustine to Wilde, Freud to Foucault* (Oxford: Oxford University Press, 1991); Rita Felski, 'The counterdiscourse of the feminine in three texts by Wilde, Huysmans, and Sacher-Masoch', *Proceedings of the Modern Language Association*, vol. 106, no. 5 (October 1991), 1094–105; Reginia Gagnier, *Idylls of the Marketplace: Oscar Wilde and the Victorian Public* (1986; rpt Aldershot: Scolar Press, 1987).

3 And, correspondingly, characters like the low-tar James Vane (Sybil's sailor brother) are not represented as smokers.

4 'The critic as artist' (1890), in Richard Aldington and Stanley Weintraub (eds), *The Portable Oscar Wilde* (Harmondsworth: Penguin, 1981), p. 87.

5 Oscar Wilde, *Complete Shorter Fiction*, ed. Isobel Murray (Oxford: Oxford University Press, 1979), p. 58.

6 'The decay of lying' (1889), in *'De Profundis' and Other Writings* (Harmondsworth: Penguin, 1973), p. 74.

7 See Christopher Lasch, *The Culture of Narcissism: American Life in an Age of Diminishing Expectations* (New York: Norton, 1978).

8 Vol. 1, p. 124, in Variorum edition (London: Macmillan, 1961).

9 T.S. Lonsdale, 'My Aesthetic Love', verse reprinted on colour lithograph (1881) for sheet-music edition, held by the Victoria and Albert Museum, London.

10 Walter Pater, *The Renaissance: Studies in Art and Poetry* (1893), ed. Donald L. Hill (Berkeley: University of California Press, 1980), pp. 188–9. This is the fourth edition of a work originally published in 1873. Significantly, the 'Conclusion' was omitted from the second edition because, says Pater in a footnote to the later edition in which it is restored, 'I conceived it might possibly mislead some of those young men into whose hands it might fall' (p. 186). Wilde could be said to be one of the young men misled by this book; and *Dorian Gray* is all about the leading astray, or seduction, of an impressionable boy. Arguably, Wilde's overturning of Victorian bourgeois norms in the novel is all the more effective because of the double transgressiveness involved in the homosexual overtones and the 'feminization' of a boy into the pleasure-seeking pursuits typically associated with women.

11 Ibid., p. 190.

12 Ibid., p. 188: 'Every moment some form grows perfect in hand or face; some tone on the hills or the sea is choicer than the rest'.

13 'The decay of lying', p. 64.

14 *A Woman of No Importance* (1893), Act III, in Oscar Wilde, *Plays* (Harmondsworth: Penguin, 1954), p. 115. In the same context, the same character remarks prophetically that 'The future belongs to the dandy. It is the exquisites who are going to rule' (p. 115).

15 *'De Profundis' and Other Writings*, pp. 45–6.

16 Ibid., p. 46.

17 Wilde, *Essays and Lectures*, 3rd edn (London: Methuen, 1911), p. 169.

18 'The truth of masks' (1885), in G.F. Maine (ed.), *The Works of Oscar Wilde* (London: Collins, 1928), p. 1016.

19 The denunciation of the novel as a 'poisonous book' occurred in an unsigned review of the first version in the *Daily Chronicle* for 30 June 1890. 'It is a tale spawned from the leprous literature of the French Décadents – a poisonous book, the atmosphere of which is heavy with the mephitic odours of moral and spiritual putrefaction – a gloating study of the mental and physical corruption of a fresh, fair and golden youth, which might be horrible and fascinating but for its effeminate frivolity, its studied insincerity, its theatrical cynicism, its tawdry mysticism, its flippant philosophisings, and the contaminating trail of garish vulgarity which is all over Mr Wilde's elaborate Wardour Street aestheticism and obtrusively cheap scholarship': Karl Beckson (ed.), *Oscar Wilde: The Critical Heritage* (London: Routledge & Kegan Paul, 1970), p. 72. The linking of 'effeminate frivolity', 'garish vulgarity' and 'cheap scholarship' as evidence of the 'mephitic odours' that make the book stink suggests again how challenging it

could seem to represent the casual pleasure-seeker as a man.

20 Roger B. Henkle, *Comedy and Culture: England 1820–1900* (Princeton, NJ: Princeton University Press, 1980), p. 313.

21 Kerry Powell, 'Tom, Dick and Dorian Gray: magic-picture mania in late Victorian fiction', *Philological Quarterly*, vol. 62, no. 2 (Spring 1983), pp. 147–69.

22 *De Profundis* (1905), in op. cit., p. 158.

23 Pater, *The Renaissance*, p. 190.

3 'BUT SHE COULD HAVE BEEN READING LADY CHATTERLEY': THE OBSCENE SIDE OF THE CANON

1 Frank Kermode and John Hollander (eds), *Modern British Literature, The Oxford Anthology of English Literature*, vol. 6 (New York: Oxford University Press, 1973), p. 449.

2 Matthew Arnold, 'The function of criticism at the present time' (1864), in P.J. Keating (ed.), *Selected Prose* (Harmondsworth: Penguin, 1970), p. 145.

3 Ibid., pp. 145–6.

4 Ibid., p. 146.

5 'The study of poetry' (1880) is described in *The Norton Anthology of English Literature* (5th edn, ed. M.H. Abrams, New York: Norton, 1986, vol. 2), p. 1441, as having been 'extraordinarily potent in shaping literary tastes in England and in America'. For a full analysis of Arnold's place in the history of English criticism, see Chris Baldick, *The Social Mission of English Criticism* (Oxford: Oxford University Press, 1983).

6 See Morris L. Ernst and William Seagle, *To the Pure . . . : A Study of Obscenity and the Censor* (London: Jonathan Cape, 1929), p. 136.

7 Lest this connection seem far-fetched, the reader is referred to the fifth edition of *The Norton Anthology of English Literature*, vol. 2. This includes all but the beginning of Arnold's essay; among the helpful footnotes is one explaining the reference to the Mapperly Hills: 'Adjacent to the coal-mining and industrial area of Nottingham (later associated with the writings of D.H. Lawrence)' (p. 1420).

8 C.H. Rolph (ed.), *The Trial of Lady Chatterley: Regina v. Penguin Books Limited* (Harmondsworth: Penguin, 1961), p. 11.

9 Ibid., p. 25; cigarettes would at the time be connoted as a working-class purchase, the cheap everyday luxury. For more on the implications of the trial from the point of view of both social and publishing history, see John Sutherland, *Offensive Literature: Decensorship in Britain 1960–1982* (London: Junction Books, 1982), chapter 1, 'November 1960: *Lady Chatterley's Lover*', pp. 10–31.

10 Rolph, *The Trial of Lady Chatterley*, p. 17.

11 Quoted in Alec Craig, *The Banned Books of England* (London: George Allen & Unwin, 1937), p. 23.

12 Ibid., p. 24.
13 Ernst and Seagle, *To the Pure . . .* , pp. 75–6.
14 Quoted in Alec Craig, *The Banned Books of England and Other Countries: A Study of the Conception of Literary Obscenity* (London: George Allen & Unwin, 1962), p. 123.
15 Rolph, *The Trial of Lady Chatterley,* p. 119.
16 Ibid., p. 118. In the next sentence, these values are exemplified in the terms of feminist cultural criticism: 'For example, the picture is put before the young girl that if she has the right proportions, wears the right clothes, uses the right cosmetics, she will become irresistible to men and that that is the supreme achievement of a woman.'
17 Ibid., p. 98.
18 'Pornography and obscenity', in D.H. Lawrence, *A Selection from Phoenix,* ed. A.A.H. Inglis (Harmondsworth: Penguin, 1971), p. 312.
19 In 'A propos of *Lady Chatterley's Lover*' (in Inglis, *A Selection from Phoenix*), Lawrence responds to whether Lord Chatterley's paralysis was meant to be symbolic:

> When I read the first version, I recognized that the lameness of Clifford was symbolic of the paralysis, the deeper emotional or passional paralysis, of most men of his sort and class today. I realized that it was perhaps taking an unfair advantage of Connie, to paralyse him technically. It made it so much more vulgar of her to leave him.
>
> (pp. 359–60)

Yet in 'Pornography and obscenity', Lawrence takes a special exception to *Jane Eyre,* which is singled out as pornographic partly because of the physical state of Rochester at the end: 'Mr Rochester's sex passion is not "respectable" till Mr Rochester is burned, blinded, disfigured, and reduced to helpless dependence' (Inglis, *A Selection from Phoenix,* p. 314). In some sense, Clifford might then be understood as a properly defunct and incapacitated version of Rochester, representing by caricature the 'counterfeit' impotence of the type of sexuality which the later novel rejects.
20 Rolph, *The Trial of Lady Chatterley,* p. 153.
21 Ibid., p. 101. The description of Wragby near the start of the novel has many points of correspondence with Arnold's description of the setting of Wragg's misadventure (D.H. Lawrence, *Lady Chatterley's Lover* [1928; rpt Harmondsworth: Penguin, 1961], p. 14):

> Wragby was a long low old house in brown stone, begun about the middle of the eighteenth century, and added on to, till it was a warren of a place without much distinction. It stood on an eminence in a rather fine old park of oak trees, but alas, one could see in the near distance the chimney of TeYou shall pit, with its clouds of steam and smoke, and on the damp, hazy distance of the hill the raw straggle of Tevershall village, a village which began almost at the park gates, and trailed in utter hopeless ugliness for a

long and gruesome mile: houses, rows of wretched, small, begrimed, brick houses, with black slate roofs for lids, sharp angles and wilful, blank dreariness.

22 Rolph, *The Trial of Lady Chatterley,* p. 70.
23 'A propos of *Lady Chatterley's Lover'*, p. 352.
24 F.R. Leavis, 'The new orthodoxy', *The Spectator,* 17 February 1961, p. 229. The following week (p. 255), the paper published a letter from Martin Turnell which gleefully quoted Leavis's opinion of the novel in 1933. In *For Continuity,* Leavis had written:

> There is no redundancy in *Lady Chatterley's Lover,* no loose prophecy and passional exegesis, and no mechanical use of the specialised vocabulary. He returns here to the scenes of his earlier work, and the book has all the old sensuous concreteness without the fevered adolescent overcharge: ripe experience is in control.

Touché . . . none the less, Leavis comes back unchastened, referring (3 March 1961, p. 291) to 'that obscure pioneer essay', and continuing:

> What was important at the time – and for long afterwards – was to insist that he had a major claim on our attention, and above all, that he was not a pornographer or anything of the kind. Now, thirty years later, things are very different. Work of critical advocacy has been carried on with some pertinacity – at the cost (I speak from painful experience) of obloquy, slander and worldly disadvantage.

'Not a pornographer', 'what was important at the time': here Leavis defends himself against the charge of inconsistency by claiming to have used precisely the strategic approach which he abhors in the case of the defence witnesses at the 1960 trial.

25 'The new orthodoxy', p. 230.
26 F.R. Leavis, *D.H. Lawrence: Novelist* (1955; rpt Harmondsworth: Penguin, 1973), p. 16.
27 On the insistence upon the relationship between literature and life in Leavis and the group of critics around him, see Francis Mulhern, *The Moment of 'Scrutiny'* (1979; rpt London: Verso, 1981).
28 *Lady Chatterley's Lover,* p. 158.
29 Leavis, *D.H. Lawrence,* pp. 28–9.
30 *Lady Chatterley's Lover* P. 144.
31 Ibid., p. 128.
32 Ibid., pp. 228–9.
33 Not, however, for F.R. Leavis, objecting in 1966 to a journalist's allusion to 'a familiar resentment and envy, often seen in Britain, that working people should be going to Florence and Majorca, and buying Beethoven long-playing records' (quoted in F.R. and Q.D. Leavis, *Lectures in America* [London: Chatto & Windus, 1969], p. 4). Leavis resents her premises:

> I myself, after an unaffluent and very much 'engaged' academic life, am not familiar with Majorca or Florence, but in those once very quiet places very much nearer Cambridge to which my wife and I used to take our children the working-class people now

everywhere to be met with in profusion carry transistors around with them almost invariably.

(p. 5)

The rebuttal is curious in its logic. The sense seems to be that since he hasn't been able to get to Spain or Italy to test the hypotheses on the ground, then at least he can speak from first-hand experience of the mob ('now everywhere to be met with in profusion') that's invaded the local retreats for overworked and underpaid dons. The foreign locations and domestic music somehow get conflated. First, if these people are trailing their trannies round East Anglia then evidently they do not have any classical LPs. And second, the working class's experience is inversely related to the Leavises': if he hasn't been able to afford to go abroad, then surely nor should they.

34 Kate Millett, *Sexual Politics* (1970: rpt London: Virago, 1977), pp. 267–8.
35 Rolph, *The Trial of Lady Chatterley*, p. 10 (the passage from the Act is there quoted in abbreviated form, as it applied to the particular publication which the jury was to consider).
36 On one occasion, however, a witness did announce his own corruption. At the 1967 trial of Hubert Selby's *Last Exit to Brooklyn*, David Sheppard, former England cricket captain and now Church of England bishop, declared himself 'not unscathed' by reading the book. At this trial, the remarkable decision was taken to have an all-male jury, as though paternalism of the 'wives and daughters' variety were a foregone conclusion in matters of literary judgement. Recalling this recently, an article in *The Guardian* (4 January 1990, p. 26) came up with a sentence which, if taken at face value, would seem to have altered the course of western history at a stroke: 'This was in keeping with the Establishment spirit of the times and the idea that men rather than women needed protection from sexual candour.'
37 Quoted in Craig, *The Banned Books of England*, pp. 31–2, from Frank Harris's biography, *Bernard Shaw* (London: Victor Gollancz, 1931), pp. 232–3, where one further sentence, italicized, concluded the quotation – '*But it is not as readable as "Ivanhoe" or "A Tale of Two Cities"*' – which is followed by three italicized exclamation marks. In *Bernard Shaw: A Reassessment* (New York: Athenaeum, 1969), Colin Wilson supplies an anecdote which seems to clarify this:

He was incapable of grasping this [postwar] poetry of spiritual bankruptcy, or D.H. Lawrence's attempt to find true values again in sex. (Although he told General Smuts [sic] at a luncheon party that every schoolgirl of sixteen should read *Lady Chatterley's Lover*, he later admitted to [Stephen] Winsten that he had never succeeded in reading Lawrence.)

(p. 267)

Barbara Bellow Watson, author of *A Shavian Guide to the Intelligent Woman* (London: Chatto & Windus, 1964), who also (p. 130) gives the quotation from Harris, makes no remark about its language, taking it straight as an illustration of Shaw's liberal views of sex education: his

endorsement of the novel's uses 'becomes even more emphatic when we realize how strongly Shaw disapproved of Lawrence's language'.

4 *LOLITA* AND THE POETRY OF ADVERTISING

1 Vladimir Nabokov, *Lolita* (1955; rpt London: Corgi Books, 1969), pp. 342, 341. All further references will appear in the text.

2 Because it had failed to secure an American publisher, *Lolita* was initially published by the Olympia Press; it came out in the United States in 1958 and in Britain in 1959 (it was reprinted by Weidenfeld four times in the first year). The comparison with the fate of *Lady Chatterley's Lover* is direct, since both were considered as possible test cases in the light of the new Obscene Publications Act. In *Offensive Literature: Decensorship in Britain 1960–1982* (London: Junction Books, 1982) pp. 28–9, John Sutherland suggests that there were two reasons why Lawrence's novel, rather than Nabokov's, was prosecuted: the 'four-letter words' and the proposed cheap publication by Penguin (the Corgi paperback of *Lolita* appeared later, in 1961).

3 See Claude Lévi-Strauss, *Structure élémentaires de la parenté* (1949), trans. as *Elementary Structures of Kinship* (Boston: Beacon Press, 1961).

4 Lionel Trilling, review of *Lolita* in *Encounter* (October 1958), cited in Norman Page (ed.), *Nabokov: The Critical Heritage* (London: Routledge & Kegan Paul, 1982), pp. 92–102. Denis de Rougemont, *L'Amour et l'occident* (1939), trans. as *Passion and Society*; and *Les Mythes de l'amour* (1961; rpt Paris: Gallimard, 'Idées' series, 1978), pp. 53–64.

5 'Omne tulit punctum qui miscuit utile dulci,/lectorem delectando pariterque monendo'; 'He who mixes what is useful with what is pleasurable gains the whole vote,/By delighting the reader as much as advising him' (Horace, *Ars Poetica*, 11. 343 ff.). Interestingly, the next lines say that this is the kind of book which makes money and gets exported.

6 Gabriel Josipovici, '*Lolita*: parody and the pursuit of beauty', i *The World and the Book: A Study of Modern Fiction* (London: Macmillan, 1971), pp. 214–15.

7 David Packman, *Vladmir Nabokov: The Structure of Literary Desire* (Columbia: University of Missouri Press, 1982), p. 53.

8 Rodney Giblett, 'Writing sexuality, reading pleasure', in *Paragraph*, vol. 12, no. 3 (1989), p. 233.

9 Ibid., p. 236.

10 Elizabeth Dipple, *The Unresolvable Plot: Reading Contemporary Fiction* (New York: Routledge, 1988), p. 74.

11 Ibid., p. 82.

12 Ibid., p. 82.

13 Linda Kauffman, 'Framing *Lolita*: is there a woman in the text?', in Patricia Jaegar and Beth Kowaleski-Wallace (eds), *Refiguring the Father: New Feminist Readings of Patriarchy* (Carbondale: University of Illinois Press, 1989), pp. 131–52.

14 Ibid., p. 133.

15 Ibid., p. 148.

16 Ibid., p. 141.
17 Dana Brand, 'The interaction of aestheticism and American consumer culture in Nabokov's *Lolita*', *Modern Language Studies*, vol. 17, no. 2 (Spring 1987), pp. 14–21.
18 Ibid., p. 14.
19 Ibid., pp. 16–17.
20 On theories of the way that advertisements are supposed to operate on their readers or viewers, see, further, chapter 7, 'Make up your mind'.
21 For more on the figure of the *passante*, see 'Walking, women and writing' and 'p/s', chapters 1 and 3 of my *Still Crazy After All These Years* (London: Routledge, 1992).
22 See ibid., chapter 9, on Freud's rereading of this story.
23 Roland Barthes, *Camera Lucida: Reflections on Photography* (1980), trans. Richard Howard (London: Jonathan Cape, 1982), p. 34; trans. modified.
24 At the beginning of Don DeLillo's novel *White Noise* (1984; rpt New York: Penguin, 1986, p. 12), this process is further parodied in the fascination with 'the most photographed barn in America'. The barn could be any barn or anything; the point is simply to take pictures of it.

5 A HAPPY EVENT: THE BIRTHS OF PSYCHOANALYSIS

1 Sigmund Freud, *An Autobiographical Study*, trans. James Strachey, rpt Pelican Freud Library, vol. 15 (Harmondsworth: Penguin, 1986), pp. 203–4; *Selbstdarstellung* (1925; rpt Frankfurt: Fischer, 1989), XIV, p. 52.
2 Ibid., p. 210 (*Selbstdarstellung*, p. 57).
3 Freud, *On the History of the Psychoanalytic Movement*, Pelican Freud Library, vol. 15, p. 75; *Zur Geschichte de psychoanalytischen Bewegung* (1914; rpt Frankfurt: Fischer, 1989), p. 153.
4 Ibid., pp. 68–9 (*Zur Geschichte*, p. 148).
5 Josef Breuer, 'Fraülein Anna O.', in Breuer and Freud, *Studies in Hysteria*, Pelican Freud Library, vol. 3 p. 79; *Studien über Hysterie* (1893–5; rpt Frankfurt: Fischer, Bücher des Wissens, 1977), p. 24.
6 Freud, *History*, pp. 70–2 (*Zur Geschichte*, pp. 149–51). For a fine reading of Freud's recounting of the contexts in which these remarks were made, see Neil Hertz, 'Dora's secrets, Freud's techniques', in Charles Bernheimer and Claire Kahane (eds), *In Dora's Case: Freud – Hysteria – Feminism* (London: Virago, 1985), pp. 236–42.
7 *History*, p. 70 (*Zur Geschichte*, p. 149).
8 Ibid., p. 69 (*Zur Geschichte*, p. 148).
9 Ernest Jones, *Sigmund Freud: Life and Work*, vol. 1 (London: The Hogarth Press, 1954), pp. 246–7.
10 In fact, Jones's account of the order of events, derived from Freud, is wrong. The Breuers' daughter was born in March, 1882, and must have been conceived not after the end of the treatment of Anna O. (which did not end until later that year), but at the point when the patient was removed to a country house outside Vienna the previous

June. The structure is similar, in that this too represented a quasi-separation (and Breuer refers in the case history to 'a holiday trip which lasted for several weeks' (*Studies*, pp. 84–5; *Studien*, p. 28), but it is significant that Freud (and then Jones) should have sharpened the dramatic outlines of the story. See Barbro Sylwan, 'An untoward event, Ou la guerre du trauma, De Breuer à Freud, de Jones à Ferenczi', *Confrontation*, no. 12 (1984), 101–22, esp. p. 105. For a suggestive reading of the oversights and insights that mark Breuer's and Freud's accounts of the Anna O. case, see Mary Jacobus, *Reading Woman: Essays in Feminist Criticism* (London: Methuen, 1986), pp. 205–28.

11 Freud, *History,* p. 72 (*Zur Geschichte*, p. 151).

12 For a fascinating exploration of Freud's fantasy of himself as a conquering hero, see the opening chapter of Malcolm Bowie, *Freud, Proust and Lacan: Theory as Fiction* (Cambridge: Cambridge University Press, 1987). A different, but I think not incompatible reading of the Freud/Breuer break and the 'responsibility' for the founding of psychoanalysis is John Forrester's 'The true story of Anna O.', in *The Seductions of Psychoanalysis: Freud, Lacan and Derrida* (Cambridge: Cambridge University Press, 1990), pp. 17–29.

6 FRANKENSTEIN'S WOMAN-TO-BE: CHOICE AND THE NEW REPRODUCTIVE TECHNOLOGIES

1 Mary Shelley, *Frankenstein; or, The Modern Prometheus* (1818; rpt Harmondsworth: Penguin, 1973), in Peter Fairclough (ed.), *Three Gothic Novels*. All further references will appear in the text.

2 See for instance Elisabeth Badinter, *L'Amour en plus: Histoire de l'amour maternel (XVII–XX siècle)* (Paris: Flammarion, 1980).

3 In *Abortion and Woman's Choice: The State, Sexuality, and Reproductive Freedom* (1984; rpt Boston: Northeastern University Press, 1985), chapter 1, Rosalind Pollack Petchesky provides a lucid conceptual history of notions of bodily rights.

4 See Rosalind Pollack Petchesky, 'Foetal images: the power of visual culture in the politics of reproduction', in Michelle Stanworth (ed.), *Reproductive Technologies: Gender, Motherhood and Medicine* (Oxford: Polity Press, 1987), pp. 57–80.

5 Monette Vaquin, 'Quelles limites au délire biologique?' in *Libération*, 1 July 1991, p. 5 (my translation).

6 A cogent account of this position, which reveals the remarkable extent to which the new technologies have indeed been the inventions of men, is provided by Gena Corea in *The Mother Machine: Reproductive Techologies from Artificial Insemination to Artificial Wombs* (New York: Harper & Row, 1985).

7 One anthology which clearly recognizes this impasse is Michelle Stanworth (ed.), *Reproductive Technologies*, note 4, above.

8 In 'Is there a woman in this text?', Mary Jacobus makes the connection between Freudian and *Frankenstein*-type scenarios of the relation between male scientific ambitions and the subordination of feminine positions, looking at Freud's 'Gradiva' text, at *Frankenstein* itself and at what comes to resemble a modern version of Shelley's story, involving the (male) discoverers of the DNA life molecule and Rosalind Franklin, a female co-researcher written out of official recognition of her indispensable contribution. See *Reading Woman: Essays in Feminist Criticism* (New York: Columbia University Press, 1986), pp. 83–109.

9 For a comprehensive collection of articles on these issues as they appeared in the United States in the late 1980s, see Sherrill Cohen and Nadine Taub (eds), *Reproductive Laws for the 1990s* (Clifton, NJ: Humana Press, 1989).

10 This became one of the principal issues in the American 'Baby M' case, when the surrogate mother decided after the pregnancy that she did not want to give up the child. For a lucid discussion of the questions raised by this case and others, see Katha Pollitt, 'When is a mother not a mother?', *The Nation*, 31 December 1990, pp. 825, 840–6.

11 Geoffrey Cowley, 'Made to order babies', *Newsweek*, November 1989, pp. 94, 96. The fact that it is the car which is chosen to epitomize the object of a consumer decision is significant in itself, and reflects the stereotypical nature of the comparison (see, further, chapter 7, 'Make up your mind'). But it is also, no doubt, prompted by the car's traditional association both with technological innovation and with the projected identity of the purchaser. Significantly, though, the car has also been a predominantly *masculine* commodity in marketing terms: rather than the relatively long-term investments of the technological toy or machine, the kinds of commodity associated with femininity have tended to be those which offer the short-term satisfactions of fashion. Yet despite the far closer historical connection of baby wishes to women than to men, no one ever suggests that the new technologies make getting a baby like getting a new dress or a haircut. Does the choice of the car for the comparison already signify a breakdown of standardized sexual differences in the area of reproduction, or does its masculine connotation simply have the effect of reinforcing the critique of hi-tech consumerism applied to babies?

12 On this point see, further, Michelle Stanworth, 'Birth pangs: conceptive technologies and the threat to motherhood', in Marianne Hirsch and Evelyn Fox Keller (eds), *Conflicts in Feminism* (New York: Routledge, 1990), pp. 288–305.

7 MAKE UP YOUR MIND: SCENES FROM THE PSYCHOLOGY OF SELLING AND SHOPPING

1 *Salesmanship Simplified: A Short Cut to Success*, ed. William T. Walsh, Managing Editor, Opportunity Magazine (Chicago: Opportunity Publishing, 1927), p. 9.

2 Walter B. Pitkin, *The Consumer: His Nature and His Changing Habits* (New York and London: McGraw-Hill, 1932), p. 35.
3 Ruth Leigh, *The Human Side of Retail Selling: A Textbook for Salespeople in Retail Stores and Students of Retail Salesmanship and Store Organisation* (New York: D. Appleton, 1921), p. 110.
4 Pitkin, *The Consumer*, p. 57.
5 Ibid., pp. 61–2.
6 For a discussion of this in a different context, see 'Soft sell: marketing rhetoric in feminist criticism', chapter 6 of my *Still Crazy After All These Years* (London: Routledge, 1992).
7 Leigh, *The Human Side of Retail Selling*, p. 169.
8 H.K. Nixon, *Principles of Selling* (1931; 2nd edn, rpt New York: McGraw-Hill, 1942), pp. 179–93.
9 Henry Dexter Kitson, *The Mind of the Buyer: A Psychology of Selling* (New York: Macmillan, 1921) p. 180.
10 Ibid., pp. 133, 134–5.
11 The allusions are to Roland Barthes, author of *Mythologies* (1957) and 'Introduction to the structural analysis of narrative' (1966).
12 Nixon, *Principles of Selling*, p. 63.
13 Kitson, *The Mind of the Buyer*, p. 5.
14 Nixon, *Principles of Selling*, p. 44.
15 Kitson, *The Mind of the Buyer*, p. 32.
16 Ibid., p. 33.
17 *Salesmanship Simplified*, p. 193.
18 Henry Foster Adams, *Advertising and its Mental Laws* (New York: Macmillan, 1916), p. 5.
19 Virginia Woolf, *Mrs Dalloway* (1925; rpt Oxford: Oxford University Press, World's Classics, 1992), pp. 62–3.
20 Kitson, *The Mind of the Buyer*, pp. 169–70.
21 Ibid., p. 170.
22 Oscar Wilde, *The Picture of Dorian Gray* (1891; rpt Harmondsworth: Penguin, 1973), pp. 27, 210.
23 Kitson, *The Mind of the Buyer*, pp. 153, 154.
24 Ibid., p. 179.
25 *Salesmanship Simplified*, p. 159.
26 Ibid., pp. 161, 162.
27 Leigh, *The Human Side of Retail Selling*, p. 172.
28 *Salesmanship Simplified*, p. 177.
29 Leigh, *The Human Side of Retail Selling*, p. 35.
30 Ibid., p. 128.
31 Ibid., pp. 122–3
32 Ibid., pp. 131, 141.
33 *Salesmanship Simplified*, p. 184.
34 ICS [International Correspondence Schools] Reference Library, *Self-Study and Development* (Scranton: International Textbook Company, 1911), Part 2, *Essentials of a Good Salesman*, p. 1.
35 Freud, *Der Wahn und die Träume in W. Jensen's 'Gradiva'* (1907; rpt Frankfurt: Fischer, 1981), p. 133; *Delusions and Dreams in Jensen's 'Gradiva'*, trans. James Strachey (1959; rpt Pelican Freud Library,

vol. 14, Harmondsworth: Penguin, 1985), p. 83.

36 See Freud, 'Trauer und Melancholie' (1917; rpt in *Das Ich und das Es und andere metapsychologische Schriften*, Frankfurt: Fischer, 1986), p. 111; trans. 'Mourning and melancholia', rpt Pelican Freud Library, vol. 11, p. 258.

37 Roland Barthes, 'From work to text' (1971), in *Image Music Text*, trans. Stephen Heath (1977; rpt New York: The Noonday Press, 1989), p. 162.

38 Barthes, *S/Z*, trans. Richard Miller (New York: Hill & Wang, 1974), pp. 15–16.

39 Ezra Pound, *ABC of Reading* (1925; rpt New York: New Directions, 1960), pp. 30–1.

Index